Color Is Everything

Master the Use of Color in Oils, Acrylics or Watercolors

by Dan Bartges

RICHMOND · THE OAKLEA PRESS · VIRGINIA

ISBN 10: 1-892538-36-9
ISBN 13: 978-1-892538-36-9

The images of the color wheel used throughout this book are repro-duced by permission of the manufacturer, The Color Wheel Company.

If your bookseller does not have this book in stock,
it can be ordered directly from the publisher.
More information can be found at the
Web site shown below,
or call our toll-free number.

The Oaklea Press
6912-B Three Chopt Road
Richmond, Virginia 23226

Voice: 1-800-295-4066
Facsimile: 1-804-281-5686
Email: Orders@OakleaPress.com

Web site: http://www.OakleaPress.com

Other Books by the Author

Winter Olympics Made Simple (1993, 1997)
Spectator Sports Made Simple (1999)

Table of Contents

Introduction:
Welcome to the Thrill of Color

Q: Can 'color sense' really be learned?
A: Yes! And it's "easier to learn than drawing."*

This book will show you how to master color. As a result, you will paint better pictures, and you will have more fun painting.

Once you understand color's great powers and boundaries, color will become your best ally at the easel, a springboard to creative expression, and an endless source of enjoyment.

Also, understanding color will spare you from the frustrations of 'guesswork painting,' frustrations that have caused countless would-be painters to quit (don't you become one!). Instead, you'll face your easel with the confidence that produces better artwork.

Each time you begin a landscape, a still life or a portrait, you will know how to select a color scheme that supports your artistic objectives and that will command a viewer's attention. As an art teacher I know tells her students, "Create paintings with irresistible color, paintings that pull people from across the room."

This book focuses on those objectives, and each chapter builds on the previous one in order to develop your 'eye for color' in a clear progression of steps.

Years ago when I first started painting, I had an older art teacher who created wonderful paintings that sold for thousands of dollars.

* "Not only can color, which is under fixed laws, be taught like music, but it is easier to learn than drawing . . ." –– Eugéne Delacroix (French artist, 1798-1863)

When advising her students how to choose successful color schemes, she said, "Rely on your intuition, and don't think about it. That's how I have always painted."

To me, those words were discouraging. Whenever I had tried relying on some inner muse for color guidance, I ended up with a colorful mess for a painting.

Weeks later, however, that same art teacher reminisced to the class about her early training in art school. She recalled that the most useful lessons she ever received were from a professor who pounded color sense into his students by making them mix and paint an endless array of little squares of exacting hues, shades, tints and groupings of colors. And it dawned on me that the skill she had called 'intuitive painting' was centered upon a well-laid foundation of careful study, acquired knowledge and disciplined practice. That's when I began studying color.

My research confirmed that the color sense of great artists is almost always rooted in their having studied and mastered color's basic properties. Some went to art school and learned color; others learned it on their own.

It's not unlike an accomplished novelist who writes page after page from pure inspiration, inspiration that's grounded in a working knowledge of grammar, sentence structure, vocabulary and plotting. You learning the fundamentals of color is just like an aspiring novelist learning the fundamentals of writing.

Color sense and painting are also comparable to playing sports. If you've ever played tennis, golf, soccer or basketball, you're already familiar with the phenomenon of second-nature skills. Like any

well-trained athlete who has mastered a sport, my art teacher had studied and practiced the fundamentals until they became second nature for her. She no longer needed to make a conscious effort to employ certain skills because, over time, she had created her own trusty, internal muse, born of and nurtured by her acquired knowledge, practice and experience.

So be patient with yourself. Once you've learned the fundamentals of color and begin practicing them, your own inner muse -- your artistic second nature -- will begin to stir and take an increasingly active interest in your artwork.

As you begin this exciting, worthwhile adventure, keep in mind what the artist Marc Chagall once said:

> "Color is all. When color is right, form is right.
> Color is everything. . . ."

Chapter 1: First, Let's Shop

Art-supply shops rank right up there with toy stores, and this book gives you a brand new excuse to visit one.

Because painting relies more on the right side of the brain (the creative side) than the left (analytical), you'll learn effective use of color much more quickly by actually doing this book's series of short assignments than by simply reading them. To help you get ready, this chapter lists the supplies you'll need. (Note: If you've done some painting already, then you probably have most or all of these items.)

Incidentally, supporting your local art-supply shop or arts-and-crafts store is always an excellent idea, especially for some extra guidance if you're just learning to paint. When you want to buy online, from a catalog or through an 800#, there are several reliable suppliers including www.utrecht.com, www.danielsmith.com, www.dickblick.com, www.cheapjoes.com, www.aswexpess.com and others.

Color Wheel
(Essential for this book)

The most widely available color wheels are produced by The Color Wheel Company (www.colorwheelco.com). This standard wheel is available in three sizes: Color Wheel™ (9 1/4" diameter), Pocket Color Wheel™ (5 1/8" diameter) and The Big Wheel™ (25" diameter, designed for classroom use). All three sizes provide the same information.

Paints

Whether you plan to paint with oils, acrylics or watercolors, purchase a small tube of these 10 basic colors: Cadmium Red (medium), Quinacridone Red (or Anthraquinoid Red, or Alizarin Crimson), Phthalo Blue, Ultramarine Blue, Cadmium Yellow (medium), Hansa Yellow Light (or Lemon Yellow), Titanium White (white is optional for watercolors), Ivory Black, Burnt Umber, and Burnt Sienna. Be sure to buy artist-grade paints instead of student grade. The pigments of higher grade paints are truer and more concentrated, so in the long run you'll use less paint, save money and mix better colors.

If you haven't decided which medium (which type of paint) to use, I recommend you start with oils because they're versatile and relatively slow drying, giving you ample time to make revisions and corrections. The benefit of acrylic paints and watercolors is that they mix and clean up with ordinary tap water, sparing you from solvents and fumes. However, acrylic paints might dry too quickly for you, and watercolors can be tricky to control.

Vine Charcoal or Pencil

If you're going to paint in oils or acrylics, buy a small package of vine charcoal sticks to sketch in your composition before painting over it. If painting in watercolors, you'll need a standard #2 lead pencil to sketch your composition before painting over it.

Paint Thinner
(For oil paint only)

Buy one small bottle (pint or quart) of odorless turpentine (a common brand is Turpenoid™). Pour the turpentine into a screw-on-top glass jar, which you'll use to moisten your brush when mixing paints and to clean your brushes at the end of each painting session. Put a folded piece of window screen inside the jar of turpentine on which to wipe your brushes. A handy alternative is the Silicoil Brush Cleaning Tank™ -- a glass jar and lid with a metal coil inside for wiping your brushes in the turpentine (this is an alternative use for the Silicoil jar, produced for Silicoil's very good brush-cleaning solution).

If you're using acrylic paint or watercolor, you'll use ordinary tap water as a paint thinner and to clean your brushes.

Cereal Bowl
(For acrylics or watercolors)

Pour water into an old cereal bowl or similar container for wetting or cleaning your brushes. Also, a roll of paper towels comes in handy for blotting and for wiping your brushes.

Spray Bottle
(For acrylics only)

When using acrylic paints, a small spray bottle (16 oz.) comes in handy to keep the paints on your palette moist with periodic sprays of water. Otherwise, the paints will start to harden in less than 30 minutes. You can buy a small spray bottle at most any hardware store.

Brushes

Responsive, high-quality brushes are important tools, and it's a good idea to select them at your local art-supply store where you can test the flex of the bristles (bristles should be flexible but not too stiff or mushy soft).

Bristles are made of natural fibers (animal hair such as hog, ox and mink), synthetic fibers (usually nylon) or a blend of both. Some experts recommend only synthetic-bristle brushes for acrylic paints.

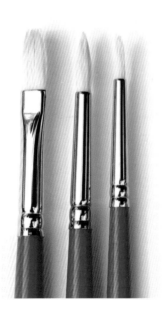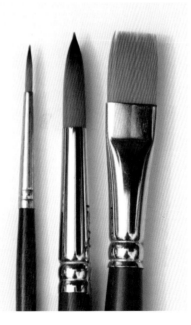

ACTUAL SIZE. The three brushes on the left are for oils and acrylics. The bristles are a blend of synthetic and natural animal hair. One brush is a flat, the other two rounds. The three brushes on the right are for watercolors. Their bristles are standard red sable. Two are rounds, and one is a flat.

Most importantly, buy high-quality brushes because they will allow you to handle paint more easily and more competently. (One of the problems with cheap brushes is that they lose their shape. Once used, the bristles of a cheap brush will splay apart at the tip, making accurate application of paint almost impossible.)

For watercolors, genuine red-sable brushes are ideal (kolinsky sable being the best but eye-poppingly expensive). There are many less expensive brushes with blends of natural and synthetic bristles that are very good, too.

Brushes come in four standard shapes: rounds, flats, brights and filberts (see illus. on facing page). Rounds come to a point and are for detail work. Brights have squared-off tips and are for spreading larger quantities of paint, as when roughing in the initial scene. Flats (also have squared-off tips but longer bristles than brights so are more versatile) and filberts (slightly rounded tips) are the workhorses and are used in most stages of a painting. You might give both a try.

Brushes come in a variety of sizes with corresponding size numbers. The problem is that manufacturers don't follow a universal numbering system. Therefore, the illustration on the facing page shows the actual sizes of the brushes suggested for this book. (Note: These are relatively small brushes because in this book you'll be creating 6" x 8" paintings in order to save you time.)

If properly cared for (cleaned and reshaped after each use), quality brushes can last for several years.

Palette

To get started with oils, acrylics or watercolors, you can simply use a disposable, white plastic dinner plate with a standard 10" diameter (don't use a paper plate because the paint will seep through). Or, you can make one by taking a foot-square piece of Plexiglass or window glass and affixing it to a foot-square of foam core (light gray or white) using 1 ½" masking tape along the edges (see illus. below). Or, you can purchase any one of several ready-made styles of palettes available for oils and acrylics or for watercolors.

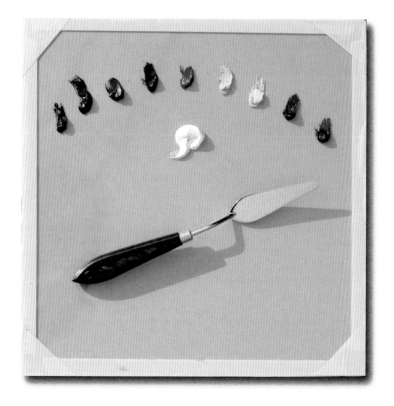

This homemade palette is simple to make. Using masking tape along the edges, affix a foot-square window glass (or Plexiglass) pane to a foot-square piece of light-gray or white foam core. This provides plenty of free space to mix colors with a palette knife.

Palette Knife
(For oils and acrylics only)

A traditional 3" palette knife is all you'll need. It's a handy tool for mixing paints on your palette and for scraping off old paint from your palette. (Some artists use a palette knife instead of a brush to apply paint.)

Easel

When it comes to easels, let your personal taste and budget be your guides. Although traditional wooden easels look great, I prefer a simple, steel tripod easel that tilts vertically for oils or acrylics and horizontally for watercolors. The type I use costs about $50, is portable, stable, adjusts for small to medium-sized paintings, and is durable (I've used mine every day for a decade).

Painting Surface

To do this book's assignments in oils, acrylics or watercolors, I suggest you buy 4 sheets of 20" x 30" Bristol board or medium-weight, smooth watercolor paper. Either type is fine.

If you're using oils or acrylic paints, you'll need to prime the front AND back surfaces of the paper with an acrylic product called gesso (buy plain white gesso; 'student' or 'studio' grade is fine for these practice assignments). Gesso is available by the pint, quart or gallon. One coat of gesso on each side of the paper is adequate for this book's assignments, but normally you would apply two coats to each side of the paper (if painting on canvas, then apply two coats only to the side you'll be painting on) before starting a painting. Acrylic gesso dries quickly, provides a stable surface and protects the paper, which eventually will degrade if the paint gets to it. (Note: Don't buy oil-based gesso; it's too troublesome to work with.)

TIP: It's quicker and easier to gesso the full 20" x 30" sheet, let it dry completely (about an hour for each side; a little longer in high humidity), then cut it into the 10" x 10" piece and several 6" x 8" sections. Some artists lightly sand the dried surface with a piece of fine sandpaper for a smoother surface; I prefer a slightly textured surface, called "tooth."

Cut out one 10" x 10" piece, and then cut all the rest of your paper into 6" x 8" pieces.

If you're using watercolors, don't gesso the paper. Your plain 10" x 10" sheet and several 6" x 8" sheets are already ready to paint on.

If you're using oils or acrylics, remember to gesso both sides of the paper; otherwise, it will warp. I use an inexpensive, 2" foam-rubber brush, available at any art supply or hardware store. Gesso cleans off easily with tap water so you can reuse the applicator brush.

Once your sheets are cut and prepared, use loops of masking tape (sticky side out) to affix a 6" x 8" card to a larger piece (about 14" x 16") of cardboard or foam core, then put it on your easel (see illus above).

Lighting

It's best to illuminate your workspace and easel with color-corrected lighting that approximates natural light (sunlight). Standard incandescent lighting is too yellow, and standard florescent lighting is too blue. Creating a painting under either type of light will throw your painting's colors off when seen in natural light. Color-corrected "daylight" bulbs and fluorescent tubes are available through most lighting-fixture stores and many art-supply stores.

YOUR DARK PAST

The next time you're out sketching, consider the fantastic drawings that prehistoric artists made by torchlight on the walls of caves. Now 15,000 to 40,000 years later, we're still sketching the exact same way they did – by using sticks of charcoal.

Chapter 2: Color Basics

In this chapter, you'll learn the fundamental properties of color. These are key to developing your color sense and competency. While color can become complicated, it's also reliably predictable. It follows what Paul Cezanne called "logic" and Eugéne Delacroix considered "fixed laws." (For a brief Glossary of Colorful Terms, see page 88.)

But enough of words. Let's get paint on your brush!

Take your ten tubes of paint, and squeeze out a pea-sized glob from each onto your palette as shown below.

On your palette, try arranging your paints in this order (from left to right): Ivory Black, Burnt Umber, Burnt Sienna, Quinacridone Red (or anthraquinoid Red, or Alizarin Crimson), Cadmium Red Medium, Cadmium Yellow Medium, Hansa Yellow Light (or Lemon Yellow Light), Phthalo Blue, Ultramarine Blue and then at center a double portion of Titanium White (white really isn't necessary for watercolors). This way, the warmer hues are on the left, and the cooler ones are on the right – similar to how your color wheel is arranged.

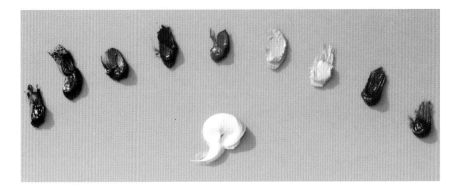

Now, refer to the color-mixing side of your color wheel (the side with the "Color Wheel" logo). This side shows, in general, how colors change when mixed with various other colors.

For example, go to RED on the outside edge of the wheel, then turn the dial until "adding white" lines up with RED (see illus. below). The wheel shows that red mixed with white produces pink. Now turn the dial until "adding yellow" lines up with RED; the result will be orange. If you haven't mixed colors before, study some of the combinations on the dial, and you'll quickly get the idea.

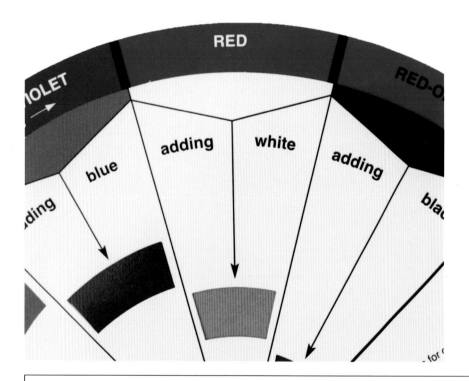

WE'RE ALL PRE-PROGRAMMED FOR COLOR?

Did you know that we're hardwired to react to colors in predictable ways? Try this quick experiment on yourself: On the next page, stare at the yellow dot in the box for a full 20 seconds, then cover the yellow dot with a piece of white paper and immediately stare at the empty dot. In a moment, yellow's complementary color (violet) will magically fill the empty dot.

As you've just proved, your brain desires the visual satisfaction of complementary colors (also called 'contrasting colors'). When your eyes' photoreceptors are overexposed to one color, your brain will automatically imagine that color's complement as a counterbalance. This phenomenon is called 'comple-

Take your palette knife or largest brush, and let's create the color pink. Wet the bristles in Turpenoid (for oils) or water (for acrylics or watercolors) and wipe it off on a paper towel. Dip the tip in the red paint and smear some elsewhere on the palette. Wipe off the red paint from your palette knife or rinse it off your brush in the Turpenoid or water, then dip the tip in the white paint and mix the white and red together on the palette (see photo below). Different quantities of each, of course, will change the red's value and intensity, but it won't change the hue (pink is still a red hue, just at a higher value and lower intensity; see Glossary, p. 88). For watercolors, simply dilute the red pigment with more water to create pink.

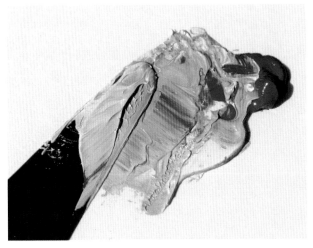

Creating pink from titanium white and cadmium red.

mentary after imaging,' and it works for any color. (Just imagine the implications for your future paintings!) Using ordinary crayons or paint and a sheet of white paper, try the experiment with other colors to discover their complements the natural way.

Next, try mixing burnt sienna (a low-intensity orange) with Hansa yellow to get a dulled yellow-orange (see below left). Then try burnt sienna with cadmium yellow. You'll see that the second yellow-orange is richer, more intense, than the first orange. Looking (below right) at part of a color wheel from page 24, you'll see that cadmium yellow is one step closer to the oranges than is Hansa yellow. Important to Remember: The closer two mixed colors are on the color wheel, the more intense their mixture. The further apart they are, the duller their mixture.

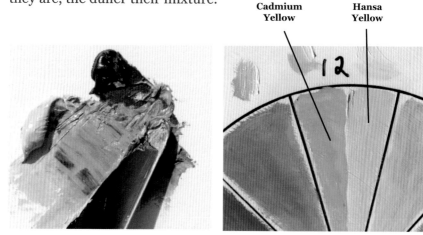

Cadmium Yellow Hansa Yellow

A mixture of Hansa yellow and burnt sienna (a dark orange hue) produces a less intense yellow-orange than mixing cadmium yellow with burnt sienna. That's because cadmium yellow is one step closer to the orange hues than Hansa yellow is. The closer two colors are on the color wheel, the more intense their mixture will be.

Try mixing ultramarine blue with cadmium yellow to get green, then mix phthalo blue with Hansa yellow to get green. The greens are very different. Which has a higher intensity? (The blue and the yellow that are closest to each other on the wheel -- phthalo blue and Hansa yellow -- will produce the most intense green. See the color wheel on p. 24). Next, add to each of your two greens a bit of white and note the changes. Add a touch of black to each. The hues get slightly darker (lower value) and duller (less intensity).

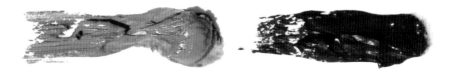

Mixing phthalo blue with Hansa yellow produces a high-intensity green, as shown at right. For a less intense, more natural green, try mixing Hansa yellow with ultramarine blue. It's less intense because ultramarine blue is one step further away from Hansa yellow (see illus. p. 24).

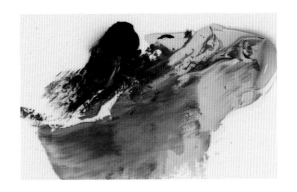

Here's a helpful drill: Try replicating the exact combinations shown on the color-mixing side of the color wheel. For example, try various mixing combinations of blues with yellows until you get the same blue-green as shown on the outside ring of the wheel. Then turn the dial, adding red to your blue-green, then try yellow, etc. – each time mixing paint until you replicate the colors that show in the little windows. You'll be surprised not only by how challenging this can be, but also by the quick progress you'll soon make.

A couple of times a week for the next month, set aside 15 minutes for mixing colors. Experiment and practice until you can accurately predict the outcomes of a broad range of color combinations. That acquired knowledge will be very useful as you and your art move forward.

Successful use of color revolves around two basic steps: 1) Determining a suitable color scheme for your painting, and then 2) Using only those colors that conform to the color scheme you've chosen. (Incidentally, don't worry that 'color rules' might cage or constrain your creativity. As you'll discover, color schemes are astonishingly versatile, and your creativity will always have plenty of elbow room. For each color, there are literally thousands of variations discernible to the naked eye.)

In Part A, we'll take a closer look at color mixing. Then in Part B, we'll examine the relationships between colors. You'll need your color wheel for both of these sections.

Your two-sided color wheel is a remarkably useful tool and your key to understanding how colors work. The color wheel is often overlooked by beginners and is often undervalued by more experienced

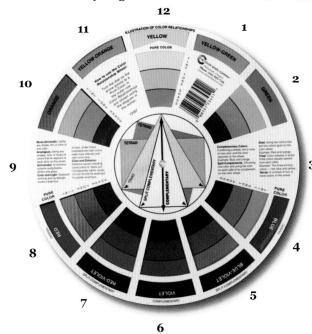

painters because few have explored its broad range of capabilities.

On your color wheel, notice that there is a dialing disk on both sides. The side with the manufacturer's label on it is the color - mixing guide. The other side - - with those geometric shapes at the center -- is for determining color schemes.

Starting on the color - scheme side (see illus. at left), let's examine how the 12 colors are organized around the wheel (they're arranged in the same order on both sides).

Think of the wheel as a clock, and put yellow at 12 o'clock. Note that violet is directly opposite at 6 o'clock because yellow and violet are 'complementary' colors (also called 'opposing' or 'contrasting' colors). Blue is at 4 o'clock, and its complement, orange, is at 10. Red is at 8; its complement, green, is at 2, and so forth. Take a few minutes to familiarize yourself with the 12 colors, their positions relative to one another, and especially with each color's complement (its direct opposite on the wheel).

These 12 main colors are classified as primary, secondary or tertiary. As you recall from school days, there are only three primary (basic) colors -- red, yellow and blue. Theoretically, all other colors can be produced by mixing pure primary colors in various combinations. On the color wheel, the three primaries take the corner positions on an equilateral triangle (see upper left illus., facing page):

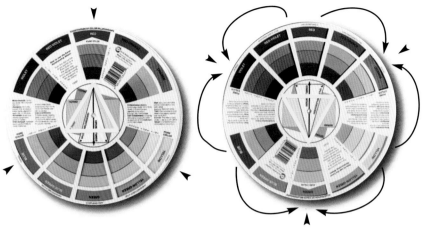

Three Primary Colors Three Secondary Colors

If you mix together any two primary colors, you'll get one of the three secondary colors (orange, green or violet), which also take corner positions on another equilateral triangle (see illus. above right).

Lastly, if you mix any secondary color with one of the primary colors on either side of it, you will produce one of six tertiary colors (see illus. at right: tertiaries are always hyphenated). For example, if you mix green (a secondary color) with blue (a primary color), you'll get blue-green (a tertiary color). Or, on the wheel you could go to the other side of green to mix it with yellow (a primary color), creating yellow-green (a tertiary color).

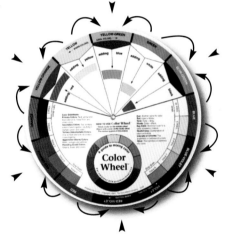

Six Tertiary Colors

Any standard 12-color wheel, then, is composed of 3 primaries, 3 secondaries and 6 tertiaries. Between any two primary colors are one secondary and two tertiaries (for example, between the two primary colors blue and yellow are green, blue-green and yellow-green).

Keep in mind that complementary colors (opposites on the wheel such as blue and orange, or yellow and violet) have a very special relationship. If placed next to each other, both colors seem to become more lively and appealing. However, if you mix the right

quantities of each together, you'll get a dark, neutral gray or a muddy, dark brown. Complementary colors, when mixed together, will always produce a darker, more neutral color. Adding just a small amount of a complementary color will slightly darken the original color's value and slightly lower its intensity. (Note: Similar results can be obtained by adding black instead of a complementary color, but the resulting color may not be quite as rich.)

When cadmium yellow mixes with its complementary color violet, yellow's value and intensity decrease as yellow moves toward a neutral gray, seen more clearly when white is added, raising its value but further reducing its intensity.

Learning how to alter a color's value and intensity is extremely important. In landscapes, for example, all colors fade with distance. The value gets lighter, and the chroma (intensity or saturation) gets weaker the further away the object is. Generally, this faded appearance is accomplished by adding the right amount of black and white or the right amount of the color's complement and white.

TIP: When you're lightening a particular color's value by adding white, also add just a bit of the next color on the wheel going up toward yellow. Otherwise, your lighter color will look bland and chalky. For example, if you want to lighten green, then add sufficient white and just a bit of yellow-green (the next color on the wheel up toward yellow). If you want to lighten red-violet, then add white and just a touch of red.

Conversely, if you want to darken a color, then add the necessary amount of black and just a touch of the next color on the wheel going down toward violet. For example, if you want to darken orange, then add black and just a touch of red-orange. Otherwise, your darker color will look muddy and lifeless.

Learning to mix and manipulate colors takes some practice. When J. M. W. Turner was asked the secret of his amazing artwork, the great English landscapist replied, "The only secret I have got is damned hard work."

PART B: Portrait of a Color Wheel

Okay, now let's mix some colors to create a color wheel. This simple exercise is a shortcut to gaining a feel for your 12 main colors and how they relate to one another.

First, squeeze onto your palette pea-size blobs of your 10 colors in the same order as before (see illus., p. 15). If you lay out your colors the same way every time, you'll know exactly where everything is and be less apt to lose your concentration when pausing to mix colors).

On your 10" x 10" sheet of gessoed paper (plain 10" x 10" sheet for watercolors), begin by drawing a circle about 8" in diameter, then divide it into 12 equal pie-shaped slices and number them like a clock face (see Illus. at right).

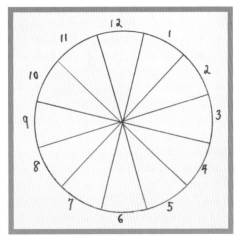

Next, paint in the three primary colors -- yellow, red and blue. Note: For each of these three pie-slice color spaces, use both the warm and the cool versions of each primary color (see "Temperature" in the Glossary, p. 90). For example, in yellow's 12 o'clock space, use Hansa yellow to paint the right-hand half (the side nearest the cool blues and greens) and use cadmium yellow to paint the left-hand half (the side nearest the warm reds and oranges; see illus. on next page).

Blue is at 4 o'clock. Use your phthalo blue on the cool side (next to blue-green's space) and the ultramarine blue on the warm side (next to blue-violet). Red is at 8 o'clock. Use cool quinacridone red (or anthraquinoid red or alizarin crimson) on the side of the pie slice next to red-violet and use cadmium red on the side next to red-orange.

For the #6 space (violet), mix the warm red (quinacridone red, anthraquinoid red, or alizarin crimson) with the warm blue (ultramarine blue). That will produce your first secondary color, violet. Make sure the violet isn't reddish or bluish to your eye – just plain, unbiased violet, and use that color to paint the entire #6 pie slice.

Next, mix phthalo blue with Hansa yellow to create your second secondary color, green, for the #2 space.

Following that, mix cadmium yellow with cadmium red to produce the third secondary color, orange, for the #10 space.

Next, create the 6 tertiary colors in respective spaces 1, 3, 5, 7, 9 and 11 by mixing the colors on either side of those spaces (for example, mix Hansa yellow with the green you produced to create yellow-green in space #1, and continue mixing primaries with secondaries around the wheel, completing your color wheel by mixing orange with cadmium yellow to produce yellow-orange in the #11 space).

Before finishing, use your palette knife to scrape up a bit of each color, smear it just outside the circle, and then mix it with white to see the radical change in value and intensity.

Your finished color wheel should look something like this:

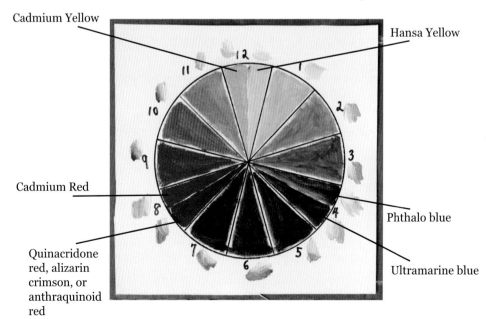

Cadmium Yellow

Hansa Yellow

Cadmium Red

Quinacridone red, alizarin crimson, or anthraquinoid red

Phthalo blue

Ultramarine blue

Chapter 3: The Best Color Schemes (and Why They Always Work)

It's a fact of Nature that only certain color combinations are harmonious and attractive -- from a flower's color that attracts a bee and a bird's plumage that attracts a mate to a beautiful painting that attracts an admirer.

Color harmony has sometimes been compared to musical harmony – harmonic chords, for example. Whether audible or visible, we all respond positively to harmonic combinations and negatively to discordant ones. Strong evidence of our shared appreciation for specific color combinations can be seen in artwork around the world, as far back as ancient China, Egypt and Italy and as recently as most any successful painting created, well, just today.

Remarkably, there are only six basic harmonic combinations, or 'color schemes.' Those six schemes are the underpinnings of virtually all successful paintings you're apt to see in your entire lifetime. (An exception would be a post-1950 strain of artwork -- mostly abstract paintings -- that celebrates the random use of color in order to separate color from aesthetic intent.)

Depending on the painting and how expertly the colors have been handled, a color scheme can sometimes be hard to discern, but with a little practice you will be able to recognize and use them all. As the artist William Merritt Chase observed, "One becomes in time so sensitive to color harmony that the instant one puts on a false spot of color it hurts, like the wrong note in music."

As we review the six color schemes, use the color-scheme side of your wheel (the side with the geometric shapes in the middle) to locate each pattern. Then take time to paint a 'color sketch' of each painting on your 6" x 8" cards. When painting your color sketch, your main objectives are to replicate the colors in the painting and to follow the general composition, but *don't* make a time-consuming copy of the painting. Instead, focus your energy on learning to accurately reproduce colors within a specific color scheme.

The 6 Color Schemes

1. A MONOCHROMATIC painting is the simplest of all color schemes. It consists of just one hue (for example, red in this paint-

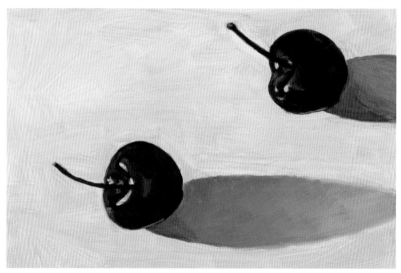

ing of cherries) that can be mixed with white and/or black for variations in chroma (intensity) and value. Because of its inherent sameness, it's often difficult to create visual interest in a true monochromatic painting. Variations in value are the key. For the rest of the book, we'll ignore this very limiting option.

For comparison, notice how the same two red cherries become significantly more attractive when a second color is added (a blue-violet mixed with white and a tiny bit of black), thereby becoming an analogous color scheme.

2. The ANALOGOUS color scheme is the monochrome's closest kin but offers the artist much more to work with. An analogous scheme consists of at least two and a maximum of five consecutive colors on the color wheel (for example, turn the dial so that blue-violet, violet, red-violet, red and red-orange show in the five consecutive windows. These five analogous colors were used for this painting of a salad-dressing bottle with grapes). More often, an analogous color scheme consists of any three consecutive colors

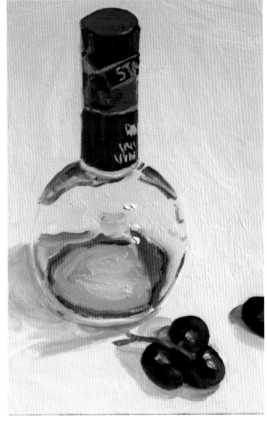

This painting uses 5 consecutive colors, the maximum for an analogous color scheme.

(usually the main color plus the ones on each side of it). Choosing analogous colors for your painting is a good, safe bet for managing color and for avoiding discord.

TIP: For an analogous scheme, it's often more visually appealing to use only 'cool' colors (for example, green, blue-green and blue) or only 'warm' colors (for example, red-orange, orange and yellow-orange). See "Temperature," p. 90.

3. The COMPLEMENTARY color scheme employs a pair of colors that are directly opposite each other on the color wheel (such as red and green, or yellow-green and red-violet; note the "Complementary" two-headed arrow through the center of the dial). All sets of complementary colors offer the unique, intrinsic 'power of opposites' that other schemes lack, which is why complements are a popular choice among artists. When placed together, complementary colors enliven one another. Historically, the most popular complementary pairing is orange and blue, particularly for landscapes.

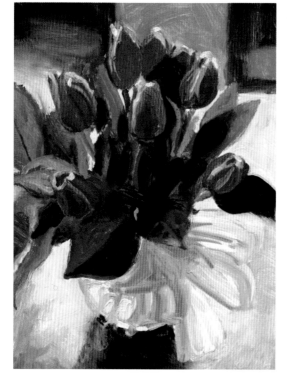

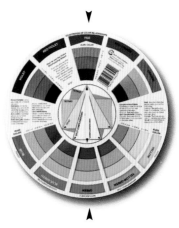

"**Margaret's Tulips**" consists of two complementary colors, red and green, which when mixed together with a little white produce the gray, also.

Note that artists often use more than one complementary pair of colors in a painting with the maximum being 6 pairs (all 12 colors on a color wheel), which would be a whopper of a challenge to orchestrate.

4. A SPLIT COMPLEMENTARY scheme uses three colors that are almost directly opposite one another – one on one side of the color wheel, the other two adjoining that color's true complement (note the "Split Complementary" setting, shaped like a slender triangle at the center of the dial). For example, set the dial's split complementary triangle to point to blue, green and red-orange, a combination often used in landscapes as in this painting "Tree above Roman Ruins." As another example, yellow forms a split complementary with blue-violet and red-violet. Because our eyes prefer harmonious variety, split complementaries often produce a more appealing painting than one relying on a single pairing of complements.

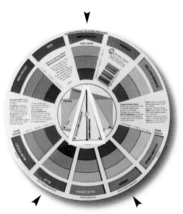

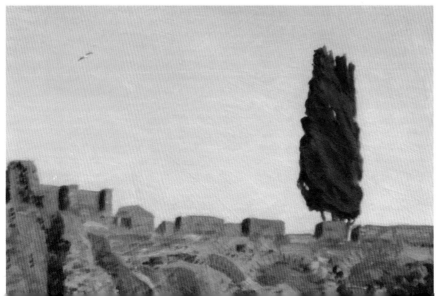

To use this color scheme, it's often helpful to first determine what your painting's dominant color will be (i. e., the color that will take up more of the painting's surface than any other color). Then add that color's split complements on the opposite side of the color wheel (for example, if green is going to be the painting's dominant color, then red-violet and red-orange would complete this scheme).

5. A TRIAD, or TRIADIC color scheme, uses three colors equally spaced apart on the color wheel that form a strong, triangular relationship. The most commonly used triad -- particularly for landscapes -- is green, orange and violet because of its versatility. The three primary colors – red, yellow and blue – comprise what's considered the most visually powerful triad. If you as the painter conclude that a triadic color scheme would suit your subject matter, you can rest assured that this scheme will produce reliable results.

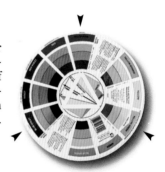

"**Blue Ridge at Dusk**" has a triadic color scheme of red-orange, yellow-green and blue-violet. The intensity (chroma) and value of each color were altered by mixing with various amounts of its complementary color, with black and/or with white (also, see TIP, p. 22).

6. A TETRAD employs four colors (which are always two pairs of complements). Because tetrads are a more complicated color scheme, they typically are more challenging to manage. They are also capable of rendering unusually rich, captivating paintings.

"Spiderwort in a Bottle" is a tetrad that pairs blue with orange, and yellow-green with red-violet.

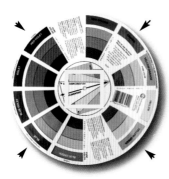

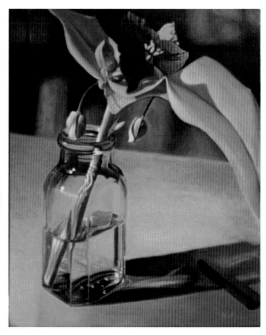

At the center of your color wheel, note that there are actually two connecting patterns for tetrads –– one that's a square, the other a rectangle. Either way, a tetrad always entails two pairs of complements, which gives the painting excellent color structure, beauty and balance.

TIP: As you develop a painting with a triad, tetrad or sometimes a split complementary color scheme, keep in mind that at some point your colors will become discordant or close to it, which will cause you to seriously question your color choices. With a triad, you'll reach that awkward moment as you apply the second color because those two colors will be so far apart on the wheel and need that third color to unite in harmony. With a tetrad, it will happen either as you apply the second or the third color, but then the fourth color will bring the scheme into harmony. Therefore, it's best to put all of your scheme's basic colors into your painting as soon as you can.

Recognizing Color Schemes

This section features a variety of paintings to help accustom your eyes to recognizing various color schemes.

With color wheel in hand, take time to study each of the following 10 paintings, then write down what you think the color scheme is (the answer is printed upside down by each painting). For a little painting practice before moving on to the next chapter, select three of these paintings and then on your 6" x 8" cards do a color study of them, devoting most of your efforts to mixing and matching the colors.

"Tea Bag with Spoon"　　　　　Color Scheme?_____.

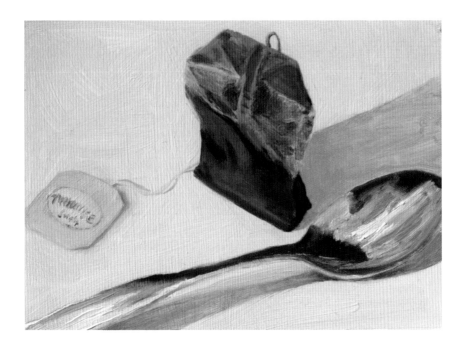

This complementary color scheme pairs various shades of orange with a grayed-down blue.

"Chesapeake Bay at Daybreak" Color scheme? _____.

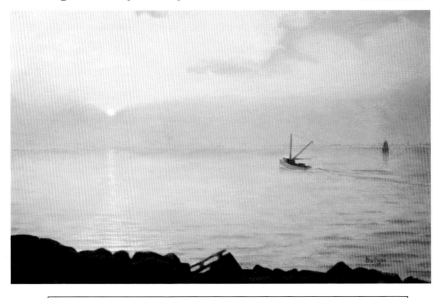

It's an analogous color scheme spanning red-orange, orange and yellow-orange. Ultramarine blue and burnt sienna were added to create the dark orange rocks in foreground.

"Girl with a Boat" Color scheme? _____.

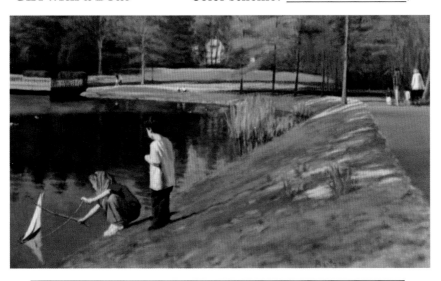

This is a tetrad pairing blue with orange and green with red. (Girl's shirt is 100% cadmium red.)

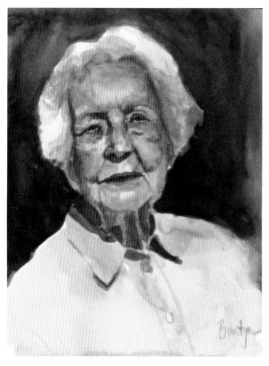

"Mary's Mom"

Color scheme?

_____.

This watercolor employs a complementary color scheme pairing red-orange with a grayed-down phthalo blue.

"Half Full" Color scheme?_____.

Similar to above, this oil also uses complementary colors -- a cool blue with a very warm orange.

"Coal Train Outside Asheville"

Color scheme?

_____.

"Jamestown, Early Morning"

Color scheme?_____.

It might be hard to tell, but it's a tetrad color scheme, pairing blue-green with red-orange and yellow-orange with blue-violet.

BREAKING THE COLOR CODE

It took the far-reaching genius of Sir Isaac Newton ("the greatest man that ever lived," declared Voltaire) to demystify the properties of light and color. His revolutionary findings changed painting forever . . . but not right away. Although he published his breakthrough discoveries of the 1660s in 1704, hidebound resistance to his findings delayed Newton's impact on the art world for a hundred years. Trailblazing artists of the 19th century such as Delacroix, Corot, Pissarro and Cezanne took his color theories to heart in their artwork – theories that have profoundly influenced Western art ever since.

Part of the credit goes to Michel-Eugéne Chevreul, a brilliant industrial chemist whose 1839 landmark book on color combined Newton's discoveries with his own observations about dyes and paints. The book became a major influence on 19th century artists.

Today, the array of color schemes in advertising, fashion and the arts can be traced back to Newton's extraordinary experiments with a simple prism and natural light.

In 1666 when Newton was still a student at Cambridge and conducting his prism experiments, he bent a linear diagram of spectral colors to form a circle and fashioned the first color wheel – just one example of his extraordinarily inventive mind.

"Spiderwort with Cup"

Color scheme?

_____.

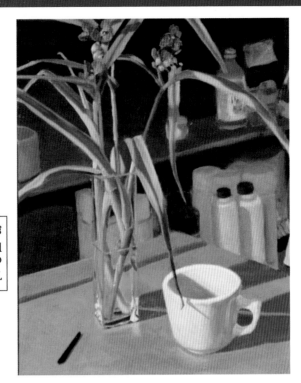

This is a tetrad. The two complementary pairs are blue with orange and yellow-green with red-violet.

"The Piano Lesson" Color scheme? _____.

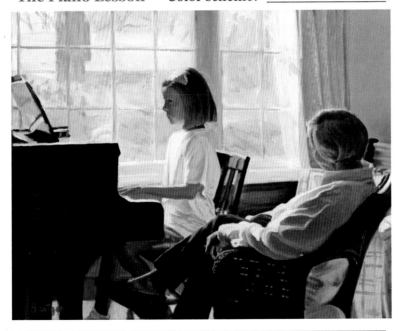

An analogous color scheme spanning red-orange through yellow-green.

Chapter 4:
How Great Artists
Choose (and Use)
Great Color Schemes

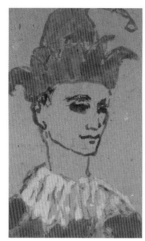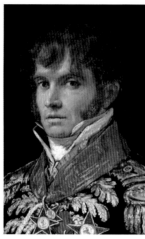

(details)

In this chapter, you'll see how great artists combine creativity with their mastery of color to produce extraordinary results. You'll also discover how surprisingly flexible and accommodating the 'rules of color' really are.

More often than not, a great artist's exceptional use of color is the signal appeal of her or his paintings. By applying confidence, perseverance, imagination, training and experience, an accomplished artist can translate color's handful of core principles into remarkably original manifestations of creativity, mood and vision.

It's sometimes helpful to remember that color's core principles are visible in paintings of all eras and schools of art, from ancient to modern, from the traditional to the avant-garde. You'll see prime examples each time you visit a favorite fine arts museum or local art gallery.

This chapter features a series of masterworks from the impressive collection of the Virginia Museum of Fine Arts (Richmond, VA). On each right-hand page, you'll be shown a painting and, with the help of your color wheel, asked to identify the painting's color scheme. On the flip side, the painting's color scheme will be discussed.

Pablo Picasso, *Jester on Horseback,*

1905, Virginia Museum of Fine Arts, Richmond, Collection of Mr. and Mrs. Paul Mellon.

On a list of the 27 highest prices ever paid for paintings, there are more Picassos (9) than any other artist.*

Like no other name, 'Pablo Picasso' defines 20th century art. Hugely influential and prolific in painting, drawing and sculpture, he was marked by boundless artistic talent as well as a dark, alienating temperament that together fueled his art and roiled his personal life.

Born and raised in Spain but spending most of his life in France, Picasso stormed through a long life (1881-1973) creating radically original artwork as "weapons" against established styles and tastes in order, he said, to make art viewers "foam at the mouth."

*Vincent van Gogh is #2 on the list with 6 paintings. Jackson Pollock claims top price ever paid for a single painting: $142.7 million.

To paint this comparatively tame yet haunting piece, what color scheme did Picasso use? _____.

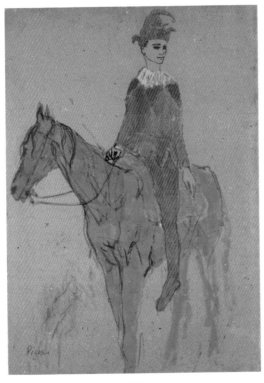

(detail)

For this oil painting on composition board, Picasso chose a unifying combination of analogous colors – ranging from the red-orange rider and pale orange background to the cool, burnt umber of the horse.

The sketchy, unfinished nature of this finished painting seems to underscore the artist's signature confidence in his work. He gives presence and three-dimensional depth to the piece by transitioning the line work and varying the degree of finish (the rider's face and right hand on the reins compared to his left arm; the horse's head, chest and front legs compared to its rear quarters that are pale and barely gestured).

During this relatively upbeat phase of Picasso's career, he often depicted jesters, harlequins and circus performers – all odd, talented individuals who exist on society's fringes and with whom, according to observers, Picasso identified.

Robert Scott Duncanson, *The Quarry,*

c. 1865, Virginia Museum of Fine Arts, Richmond, Gift of
The Council of the Virginia Museum of Fine Arts.

Reflecting the stylistic influence of the Hudson River School, this Romanticized landscape seems to pose an objection to the industrialized world's encroachment upon early America's natural yet fragile beauty. Already, laborers from the nearby factory town have stripped away the forest's groundcover and gouged out building stone from this once-pristine setting.

Born in New York and reared in Michigan, Robert Duncanson (1821-1872) became one of the most prominent African-American artists of the 19th century.

What's Duncanson's color scheme? _____.

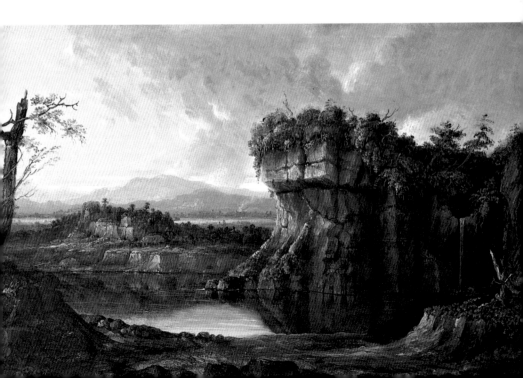

Duncanson selected a triadic scheme of tertiary colors – blue-violet, yellow-green and red-orange. Note how he intermingles red-oranges with blue-violets in the accumulating clouds, which helps create a relationship to the raw, red-orange soil and the pale, blue-violet water. Establishing these sometimes subtle color kinships helps knit together and unify the entire painting.

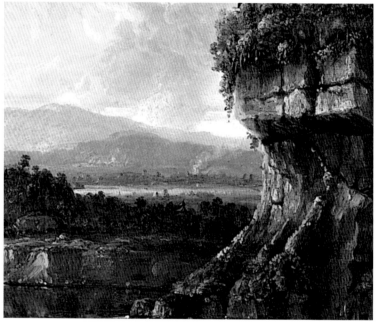

(detail)

Notice also how the near shoreline (starkly silhouetted against the water), the top of the cliffs and the dead tree (both silhouetted against the sky), and the pale, grayed-down mountains all help to establish a distinct foreground, middle ground and background, giving great depth to the scene. Duncanson furthered the effect by using warm colors in the foreground and cool ones in the background.

Severin Roesen, *The Abundance of Nature*,

c. 1855, Virginia Museum of Fine Arts, Richmond, The J. Harwood and
Louise B. Cochrane Fund for American Art.

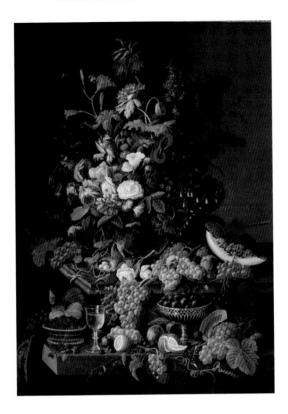

This sumptuous painting typifies Severin Roesen's still lifes. Recalling the Dutch still-life tradition, his work reflects a career-long fascination with the fruits, flowers and other sundry objects he portrayed in rich color and fastidious detail.

At 33, Roesen (1815-1874) immigrated from Germany to New York City and a dozen years later settled in Williamsport, PA, where he established a studio. Not much is known of Roesen's life, but after he died a local newspaper remembered him as a "genial, well read and generous companion, smoking his pipes and drinking his beer, and he was seldom without this beverage."

What color scheme did Roesen use to paint this complex arrangement of fruits and flowers? _____.

To portray this tower of color, Roesen managed four pairs of complements -- orange with blue, yellow with violet, green with red and yellow-green with red-violet. The result demonstrates an impressive balancing of warm and cool hues.

It's worth noting that, while artists usually employ only one or two pairs of complementary colors in a painting, you can add as many pairs as you feel you need because complementary colors balance each other.

Notice also how Roesen provides a sense of stability to this very vertical, and potentially unwieldy, composition. He uses the sturdy framework of a pyramid and places the heavier objects, as if ballast, at the bottom of the arrangement.

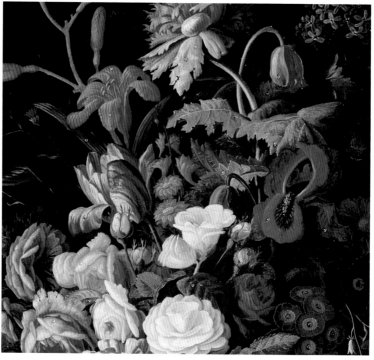

(detail)

**Eastman Johnson, *A Ride for Liberty –
The Fugitive Slaves, March 2, 1862*,**
Virginia Museum of Fine Arts, Richmond, The Paul Mellon Collection.

This emotionally charged scene of a slave family's desperate escape during the Civil War is boldly depicted by American artist Eastman Johnson (1824-1906). Injecting eye-witness candor into this drama is the following notation that the artist himself wrote on the back of the painting: "A veritable incident in the Civil War seen by myself at Centerville on the morning of McClellan's advance to Manassas, March 2nd, 1862. Eastman Johnson."

Did the family escape to freedom? Probably, because Johnson would have been on the Union's side when the horse and riders galloped past him.

What was Johnson's color scheme? _____.

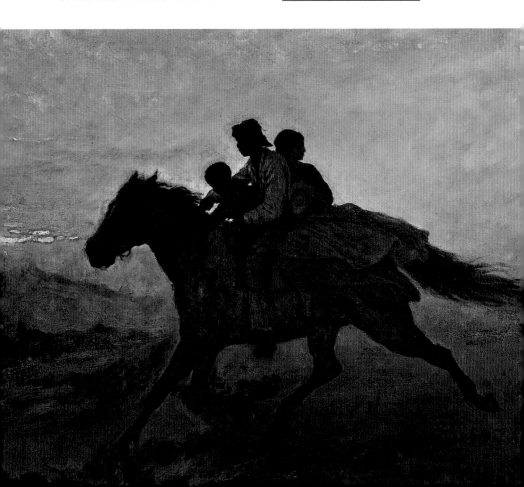

A

Johnson employed the classic complementary color scheme -- blue and orange. Contrasting colors are a superb choice to convey this scene that's all about contrast and conflict: freedom and slavery, war and peace, black and white, the transition from night to day, heading north from south, two different generations, and simultaneously looking forward to a bright future and backward to a dark, still-threatening past. There's no doubt that these symbols and undercurrents coursed through Johnson's mind and brush as he

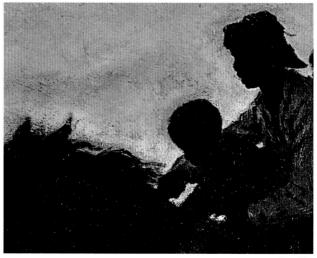

(detail)

painted his gripping, eye-witness account.

Notice also how the artist expresses a unifying sense of speed through the streaming mane, dress and tail.

During his career, Johnson painted many scenes of simple American life and in 1857 lived and painted among the Ojibwe Indians in frontier Wisconsin. In addition, he was in much demand as a portraitist by prominent Americans including Lincoln, Adams, Hawthorne, Emerson and Longfellow.

Francisco Goya, *General Nicolas Philippe Guye*,
1810, Virginia Museum of Fine Arts, Richmond, Gift of John Lee Pratt.

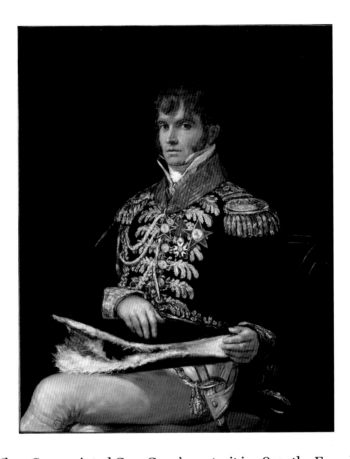

When Goya painted Gen. Guye's portrait in 1810, the French general was part of the occupation force that ruled Goya's native Spain from 1808 until 1813 under Joseph I, Napoleon's brother. The brutality of Napoleon's soldiers became the subject of this gifted artist's best known painting, "The Third of May, 1808," created in 1814. Goya (1746-1828) was a court favorite when Spanish kings were in power, too, receiving royal commissions and official status from three Bourbon monarchs (Charles III, Charles IV and Ferdinand VII).

What color scheme did Goya use to paint the French general?

_____.

A

Beautifully rendered, the general's portrait is further enhanced by Goya's choice of a split-complement color scheme using blue, red-orange and yellow-orange (and black). Certainly, he could have chosen an analogous color scheme of, say, yellow-orange, orange and red-orange (and black), but it would have lacked that masterful touch of blue. Test what a difference it makes: with your fingertip cover the blue ribbon at Guye's neck. Immediately, the portrait's punch is diminished. Also, Goya integrates the painting with touches of blue (in the subject's eyes, shirt collar and medals as well as the blue ribbon) to help unify the work.

Rendered completely deaf by a raging fever in 1792, depressed by the death of his wife in 1812, disillusioned and embittered by the Napoleonic Wars, and possibly suffering from lead poisoning from his oil paints, Goya became increasingly withdrawn and pessimistic while his artwork grew more emotionally intense and dark, especially in his 14 famous "Black Paintings" of about 1820. The artist's bold colors, daring brushwork and emotionally-charged imagination were an inspiration to future artists such as Edouard Manet and Pablo Picasso.

(detail)

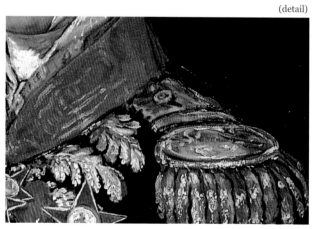

Goya often applied paint very thickly to his canvases -- a technique called impasto, used frequently by artists to highlight the brightest areas. The encrusted paint actually catches more light so seems even brighter.

Hilaire Germain Edgar Degas,
At the Races: Before the Start,
c. 1885, Virginia Museum of Fine Arts, Richmond, Collection of Mr. and Mrs. Paul Mellon.

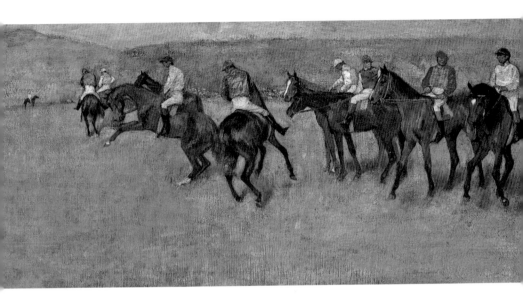

Degas' horses are magnificent creations, but the artist didn't stop there. His color scheme and carefully planned composition play key roles in attracting and holding the viewer's attention.

As Degas (1834-1917) developed as an artist, race horses and dancers became two of his favorite and ultimately most famous subjects. They are presented in hundreds of his paintings and drawings beginning in the 1860s. Several of the themes and approaches he successfully worked out in his race track paintings and drawings are later reflected in those featuring dancers.

What color scheme did Degas use for this painting, and how does his composition strengthen the piece?_____.

Maybe the most deceptively simple painting in this book, "At the Races" is actually quite complex in both its color and composition and illustrates Degas' subtle genius and craftsmanship.

If you closely examine the painting, you'll discover 6 pairs of complements (all 12 colors on the color wheel), some colors no more than flecks. The painting's strongest compositional element is the diagonal formed by the horses (from the upper left corner to the lower right). This strong structural device is used in several of Degas' race track works and later in many of his paintings of dancers. Also, here he uses the riders and horses to break up the three, potentially boring, parallel bands of sky, hills and field.

He injects a realistically tense, impatient mood into the pre-race scene by showing two high-strung horses beginning to buck and jostle their riders. Notice also the lone horse and rider in the distance on the left side – placed strategically to maintain balance and interest in an otherwise vacant area of the painting. (You can test its visual importance by covering the tiny horse and rider with your fingertip.) Typical of Degas' studio artistry, everything has been very thoughtfully planned out and well executed.

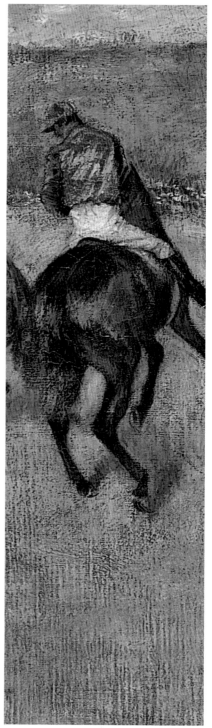

(detail)

Milton Avery, *Greenwich Villagers,*

1946, Virginia Museum of Fine Arts, Richmond, Gift of M. Knoedler and Company, Inc.

Milton Avery (1885-1965) was a married, 43-year-old[1] factory worker doing art on the side when he sold his first painting in 1928.[2] A year later, The Phillips Collection (Washington, D. C.) purchased the first of a number of his works for its prestigious collection, and in subsequent years many museums followed suit.

What color scheme did Avery choose for this painting?

_____.

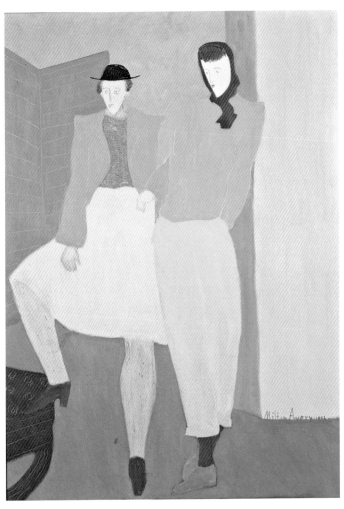

Avery puts an innovative color scheme to work here to convey Greenwich Village's contemporary stylishness of the 1940s and '50s. While the artist uses two sets of conventional complements (the various blue-violets with yellow- oranges, and the various blues with oranges), he adds two assertive colors (the red-violet of the stockings, and the red-oranges of the kerchief, socks and piece of furniture) without their counterbalancing complements. As a result, the accent colors give the overall scene a hip, edgy, modernistic appeal in step with the two stylish Bohemians.

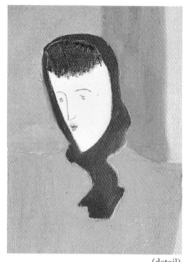

(detail)

If you cover up the painting's accent colors (the red-violets and the red-oranges), the remaining pastel hues become calm and harmonious to a fault.

Avery has been called "an American Matisse" because his style and emphasis on color were influenced by the French master's work. A very prolific artist (sometimes producing half a dozen paintings and studies a day), Avery's thousands of oils and watercolors are distinguished for their subtle yet luminous color harmonies and for his simplification of forms, which bordered on abstraction as his career progressed.

In turn, Avery and his artwork became a seminal influence on the Abstract Expressionists of the 1950s and '60s such as Mark Rothko and Helen Frankenthaler. Avery's advice to aspiring artists: "Keep painting – day in, day out."

[1] According to the Smithsonian's archives, around 1924 Avery altered his birth year from 1885 to 1893, apparently to draw closer to the age of Sally Michel, the 22-year-old illustrator he was dating then and married in 1926. Therefore, some sources show 1893 as his birth year.

[2] The buyer was Hollywood musician Louis Kaufman, whose violin can be heard on sound tracks for many movies including "Gone with the Wind," "Casablanca," "The Grapes of Wrath" and "The Sound of Music." In subsequent years, Kaufman bought more than two dozen paintings by Avery.

Willem de Kooning, *Lisbeth's Painting,*

1958, Virginia Museum of Fine Arts, Richmond, Gift of Sidney and Frances Lewis.

 Boldly abstract and contemporary, this work by a leading Abstract Expressionist features an unexpectedly sentimental twist. When de Kooning returned to his studio after finishing this painting the previous day, he discovered that his 2-year-old daughter had also been in the studio and, with paint on her hands, had added some finishing touches of her own. De Kooning decided to leave her handprints and entitled the 4' x 5' painting after her.

What color scheme did de Kooning use? _____.

(detail)

This abstract landscape is a prime example of a split complementary (using blue, yellow-orange and red-orange). If you cover the blue with your fingers, you'll see that the piece might have worked with an analogous color scheme, but minus the rich vitality of the actual painting.

Born in The Netherlands, de Kooning (1904-1997) attended the Rotterdam Academy of Fine Arts. At 22, he slipped aboard a ship, made it to the U. S. as a stowaway, and began working as a house painter. Married in 1938, he was too poor during the 1940's to buy artists' paints so used enamel house paint on his canvases. His 1953 exhibition in New York, however, caused a sensation because of his bold style and the "deliberate vulgarity" of his portraits of women. De Kooning went on to exert tremendous influence upon the contemporary art world, prompting Jim Dine to call him "our most profound painter."

Gustave Caillebotte, A Man Docking His Skiff,

1878, Virginia Museum of Fine Arts, Richmond, Collection of Mr. and Mrs. Paul Mellon.

Gustave Caillebotte (1848–1894) was a man of many interests and seems to have excelled at all of them. For a period of his life, one of his interests was paintings – both buying and creating them.

Born to a wealthy family, he was well educated and licensed to practice law in 1870. Instead, Caillebotte entered Paris' prestigious Ecole des Beaux-Arts to study painting and befriended a renegade band of artists including Degas, Monet, Renoir and Pissarro. He provided crucial financial support to the Impressionists by purchasing many of their paintings and, at least for Monet, by paying his studio rent. Caillebotte's own paintings were included in all but one of the Impressionists' controversial shows in Paris.

What color scheme did Caillebotte choose to create this scene's quiet beauty? _____.

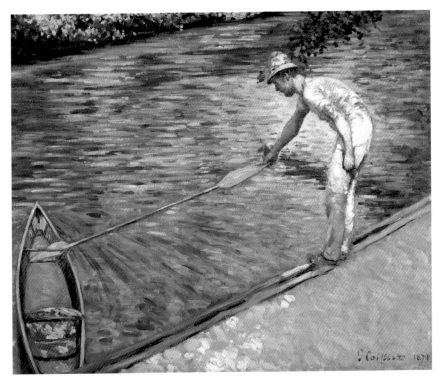

(detail)

Caillebotte made the most of a basic triadic color scheme (violet, green and orange) by tweaking it. On one of your 6"x 8" cards, spend time copying the painting's fragment on this page. You will learn how he carefully pushed some of the oranges as accents toward yellow-orange and red-orange, some of the violets toward blue-violet and red-violet, and some of the greens toward blue-green and yellow-green. Although these accents don't conform to the basic triadic color scheme, they all work harmoniously within the painting because they are all complements of one another.

As an artist, Caillebotte produced his best works from 1875-82, moved to an estate on the Seine outside of Paris, and gradually drifted away from painting as other interests seized him, particularly horticulture and sailboat racing. He also collected stamps; his collection is now in the British Museum.

Caillebotte, who died at 45 while tending his flower garden, is also remembered for his huge Impressionist art collection, a large part of which he donated to the French government. Another sizeable portion is owned and exhibited by the Barnes Foundation near Philadelphia, PA.

Alfred Sisley, *The Thames at Hampton Court*,
1874, Virginia Museum of Fine Arts, Richmond, Collection of Mr. and Mrs. Paul Mellon.

Toward the end of Alfred Sisley's life, a friend wrote that this Impressionist seemed resigned to obscurity and to sense that "no ray of glory would shine upon his art in his lifetime." As if on cue, almost immediately after he died of cancer at age 59 and poverty stricken, Sisley's paintings began to rise in recognition and value. This was partly due to Claude Monet's heroic efforts to find buyers for his longtime friend's many unsold paintings in order to help Sisley's children. Sisley (1839-1899) is the only major Impressionist who did not reap some measure of prosperity during his lifetime.

To portray this picturesque scene in England, what color scheme did Sisley choose? _____.

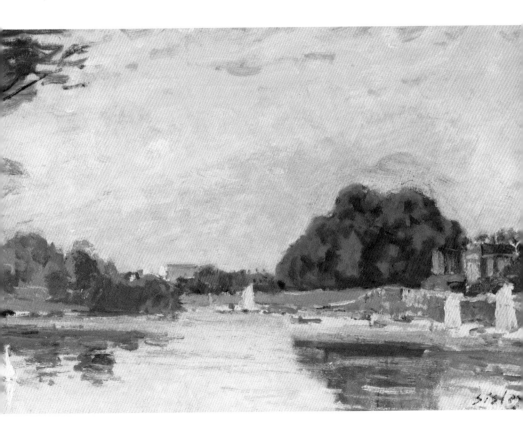

A

The renowned art teacher and artist Robert Henri once said that by studying the brushwork of a painting one could tell exactly what mood the artist was in when he or she painted it. Certainly, Sisley was in an exuberant mood when he created this masterpiece. It owes its success to bold brushwork, contrast in values and a lively color scheme featuring four pairs of complements (blue and orange, green and red, blue-green and red-orange, and yellow-green and red-violet).

Over the years, art historians have suggested a number of reasons why Sisley's artwork was so slow to gain fame. One recurring explanation is that, unlike Monet, Renoir and the other Impressionists, Sisley was not French. His parents were English, and although Sisley spent his life in France, he was never able to obtain French citizenship.

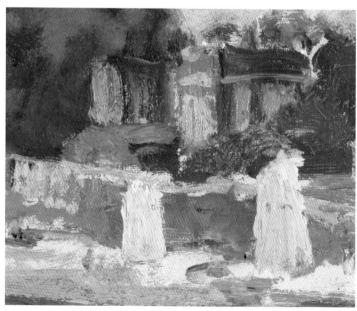

(detail)

Edouard Vuillard, *Vase of Flowers,*

c. 1900, Virginia Museum of Fine Arts, Richmond, Collection of Mr. and Mrs. Paul Mellon.

Was this contemporary painting really created more than a century ago? The individualistic style of French artist Edouard Vuillard (1868-1940) does seem perfectly in sync with today's art world. While a student in Paris, he became friends with Pierre Bonnard and the short-lived group of post-Impressionist avant-garde artists known as the Nabis.

What color scheme did Vuillard employ to paint this captivating still life? _____.

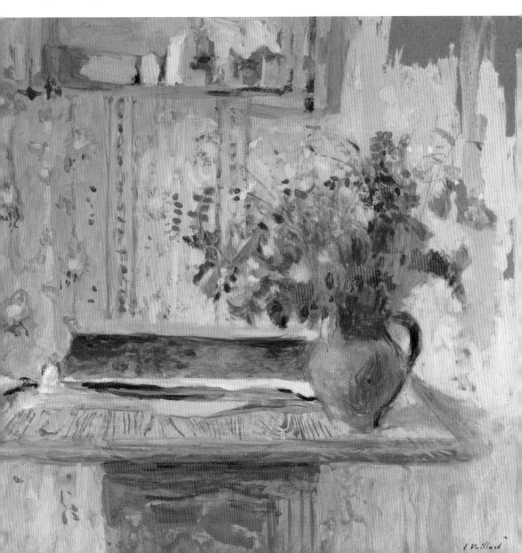

(detail)

 An artist I know counts this painting among his all-time favorites. On first impression, the color scheme might appear to be a straightforward tetrad consisting of reds with complementary greens and of blues with complementary oranges. But Vuillard, flexing his creative mastery of color, enriched the still life by adding touches of red-violet with yellow-green, blue-violet with yellow-orange, and some blue-greens paired with complementary red-oranges. All this -- orchestrated subtly and with soft colors -- achieves head-turning results, mainly because of the contrasting values and opposing colors of the light, cadmium-red flowers set against the dark greenery. That contrast of colors and of values sparks the entire painting.

Vuillard was 16 when his father, a military officer, died, and Vuillard continued to live with his mother until he was 60. Vuillard's mother was a dressmaker, and his paintings – usually of intimate interiors with subdued color schemes -- make lavish use of design patterns in women's clothing, upholstery fabrics and wallpaper. He also created theatre scenery as well as decorative panels for private homes.

Élisabeth-Louise Vigée-Lebrun, *The Comte de Vaudreuil,*

1784, Virginia Museum of Fine Arts, Richmond, Gift of Mrs. A. D. Williams.

What an improbable, whirlwind life this female artist led across 18th/19th-century Europe. The daughter of a portrait painter and described in her own time as pretty, charming, witty, optimistic, very talented and at times societally scandalous, Vigée-Lebrun (1755-1842) became one of the most successful and prolific portrait painters in history.

The fateful event of her life occurred in 1778 when at 23 she was summoned to Versailles to paint a portrait of Queen Marie Antoinette, whose subsequent friendship and patronage became both a blessing and a curse. More than six decades later, the artist died in Paris at the age of 87, having outwitted, outrun or outlived a host of husbands, lovers and political enemies.

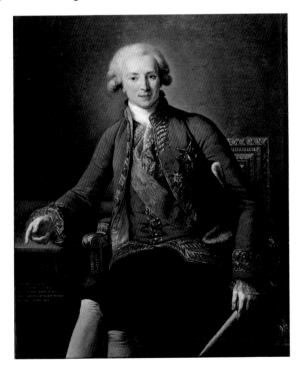

For this privileged aristocrat's portrait, what color scheme was used? _____.

For the portrait of this son of the governor of a French colony in the Caribbean, Vigée-Lebrun chose the tetradic color scheme of blue, orange, green and red. The touch of complementary green on the chair's arms and back enliven the Comte's red silk rosette; his coat's embroidered trim seems to echo the chair's ornate design. But it's that bold, diagonal slash of complementary blue against dark orange that grabs the viewer's attention. Artfully subtle touches of blue in the shadows of the sitter's wig, collar and hose help unify the painting.

(detail)

Vigée-Lebrun left behind nearly 900 paintings including 660 portraits, many of prominent figures in Europe and Russia, as well as a fascinating memoir, published in 1835 and 1837 (full text at http://digital.library.upenn.edu/women/lebrun/memoirs/memoirs.html#XVIII). Sir Joshua Reynolds, the great 18th-century portraitist and head of the British Royal Academy, once said that Vigée-Lebrun's paintings were "the equal of any portrait artist, living or dead . . . "

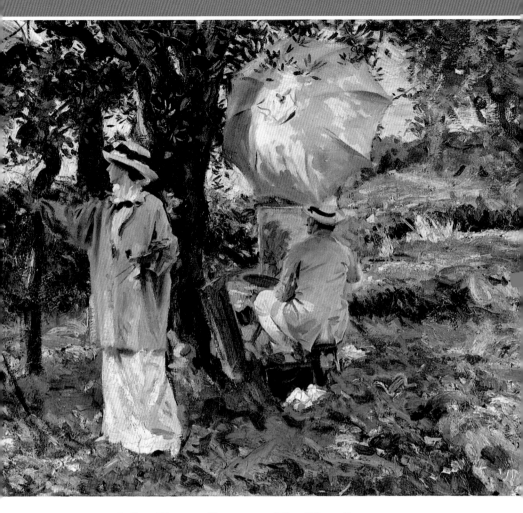

John Singer Sargent, *The Sketchers*,
c. 1913, Virginia Museum of Fine Arts, Richmond,The Arthur and Margaret Glasgow Fund.

Lively, breezy and beautifully crafted, this painting by Sargent (1856-1925) displays his mastery of color as well as his trademark brushwork, always bold and confident. The focus is a couple painting the Italian landscape, which is concealed from our view by the trees' foliage and an artist's shade umbrella.

What color scheme did Sargent use to paint this scene?
_____.

For this painting, Sargent applied a relatively complicated color scheme – a tetrad of red, green, blue and orange – that ably conveys a joyous, carefree day of painting in the countryside.

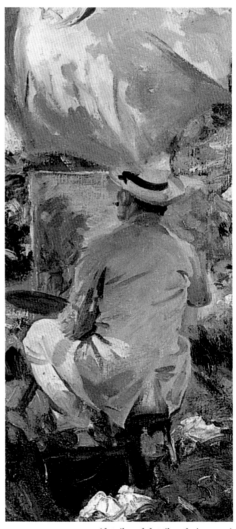

Born in Florence to American parents, Sargent showed promising talent as a child, became well-schooled in art and later earned fame and fortune by creating larger-than-life portraits of wealthy patrons on both sides of the Atlantic. His landscapes display equal mastery of oils and of watercolors. Sargent lived mostly in England and traveled extensively, spending a total of only eight years in the U. S.

Notice how your eyes roam around the painting and finally settle on the woman's face, which is prominently featured against the dark trunk of an olive tree and is more developed than the rest of the painting.

On a pilgrimage once to Giverny to paint with the French luminary Claude Monet, Sargent expressed amazement that the famous Impressionist never included black on his palette.

(detail, and detail on facing page)

"How do you do it?" he exclaimed to his host. (Monet used complements to darken colors and made 'black' by mixing darks like ultramarine blue and burnt sienna.)

Interior architectural rendering of Atrium. Rendering © 2004 Rick Mather Architects

Chapter 5: How to Plan Your Next Painting's Color Scheme

In this chapter, you'll put into practice what you've reviewed so far. You shouldn't expect miracles just yet (although they will come as you and your inner muse progress), but you will begin to notice a marked improvement in your color choices, in your overall control of your paintings and in your level of confidence.

This chapter features photos of actual subjects for you to analyze with your color wheel and then paint on your 6" x 8" cards. Keep in mind that when deciding what colors to use for any "next painting," there will always be more than one suitable color scheme for any subject.

On each right-hand page, you'll be presented a photo of an actual person, an object or an outdoor scene. Then – before you turn the page – you'll be asked to 1) Use your color wheel to determine at least two suitable color schemes, and then to 2) Use one of those schemes to do a painting of the picture (in oils, acrylics or watercolors). After you've completed your painting, turn to the next page where I'll share my painting of the same subject and explain my color choices.

So grab your color wheel, prepare your palette, and let's have some serious fun painting!

This wedge of orange could be painted in several different ways. After checking with your color wheel, write down two suitable color schemes:

1. _____.

2. _____.

Now, using one of those schemes, paint the wedge of orange on one of your 6" x 8" cards. When you've finished your painting, turn the page, and I'll share my painting and discuss its color scheme.

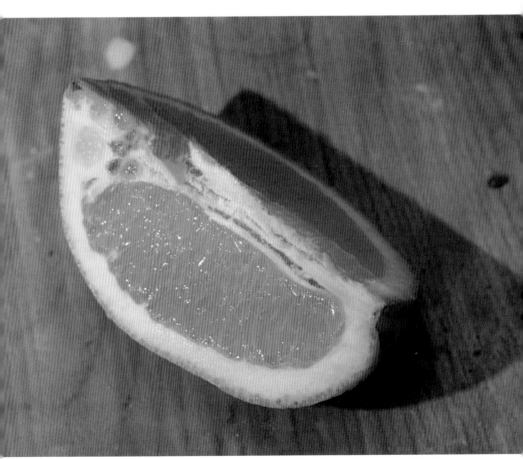

"Wedge of Orange"

Your first thought and mine were probably the same -- an analogous color scheme spanning a light yellow-orange on down to a dark red-orange. For more visual umph, I went with the harmonious contrast of complementary colors – a bright orange and a rich but muted (low chroma) blue.

Another successful route would have been a split complement using bright orange for the orange, and then a more muted blue-green for the tabletop and blue-violet for the shadow.

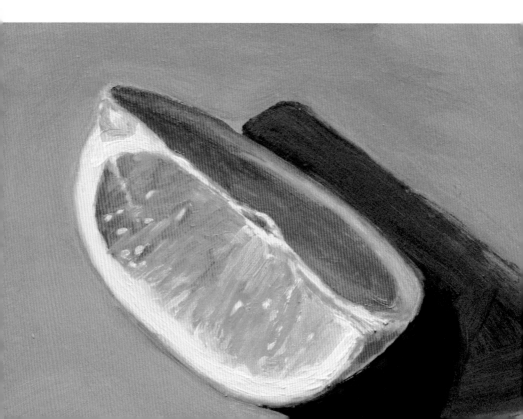

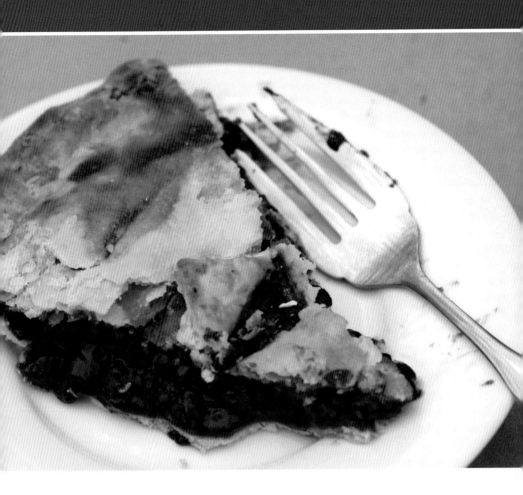

This slice of homemade pie looked good enough to paint. For me, the challenge was how to depict three very different textures: the pie's crust, the blueberry filling and the stainless steel fork. What are two color schemes that would work well for this still life?

1. _____.

2. _____.

Using one of your color schemes, paint this slice of blueberry pie on a 6" x 8" card. When you finish your painting, turn the page.

With the crust already orange and the filling a rich violet, I simply made the tabletop green to form a triadic color scheme. Note that the green is muted to emphasize the pie.

An analogous color scheme would also have worked well, going from orange for the crust to maybe a dark, low-chroma red tabletop, and then violet for the pie's filling.

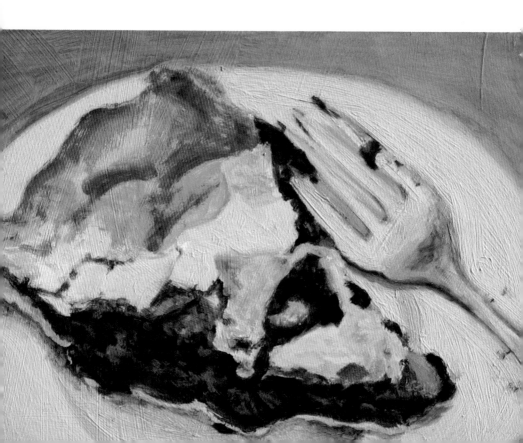

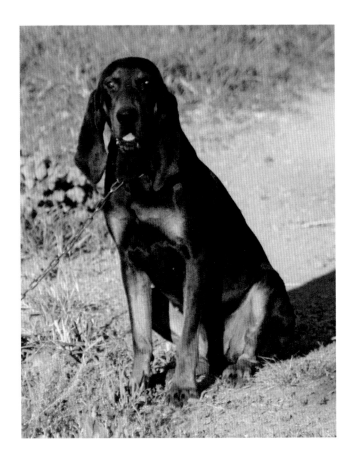

While scouting for a location to paint in Virginia's Allegheny Mountains, I met this slobberingly friendly hound dog named "Annie" and ended up painting several landscapes on her owner's riverfront farm.

What are two color schemes that would work well for a painting of Annie?

 1. _____.

 2. _____.

Choose one of them to paint her picture on a 6" x 8" card. Once you've finished, turn the page to review the color scheme I selected.

I went with a higher degree of realism for this dog's portrait in an attempt to capture Annie's healthy good looks and doggone likeable face. The rich red-orange of her coat and the yellow-green grass made blue-violet for the shadow an easy choice, completing a triadic color scheme.

A tetrad would have been a good way to go, too, pairing green grass with light, low-chroma red clay dirt and then orange in the dog's coat paired with a muted blue shadow.

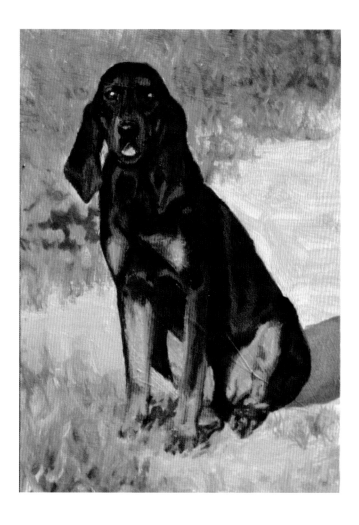

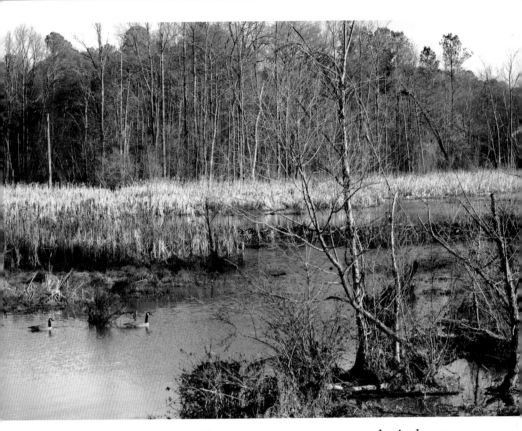

Better paint it quickly! Across our country, ecological wonders like this marshland are seriously threatened by aggressive developers and insufficient regulations. One way to help stimulate public awareness of and support for wetland conservation is to create landscape paintings of these fragile, priceless habitats.

Arrange to display your artwork in a public library or art gallery. Also, ask your local government to turn your marshland paintings into fine-art prints and greeting cards for sale -- with all proceeds earmarked to help pay for wetland-protection and wetland-education projects. These tactics work!

To portray the Tuckahoe Creek Marsh, use your color wheel to figure out two suitable color schemes.

1. _____.

2. _____.

Now employ one of the color schemes to paint this marshland on a 6" x 8" card. When you've finished your painting, turn the page.

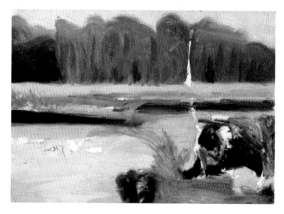

Landscapes are best done on site because, unlike looking at a photograph, all the actual colors are apparent. Plus, you'll enjoy the natural sounds and setting while you paint it.

"Tuckahoe Creek Marsh"

When creating a painting using oils, acrylics or watercolors, start by roughing in the main shapes, establishing the basic values and using the fundamental colors you've selected for the painting's color scheme (see above illus., and TIP, p. 31). In this case, I used the complementary color scheme of orange and blue. Another good color combination for this scene would be a split complementary of blue, red-orange and yellow-orange.

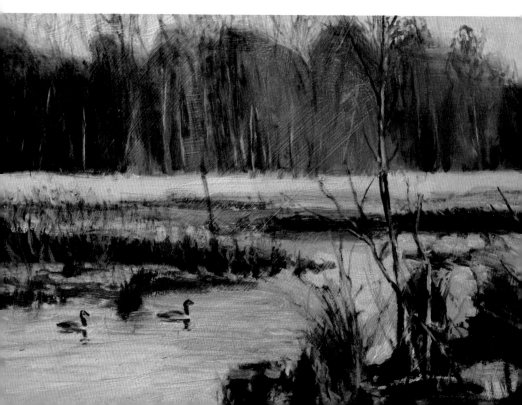

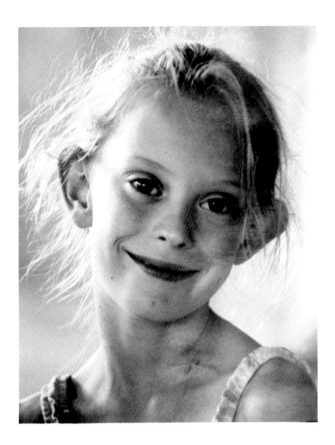

The secret behind a good photo-based portrait is, of course, a darn-good photo. And this charming photo seemed to capture the personality of a neat little girl.

With the aid of your color wheel, determine two different color schemes that would work well for a portrait of Whitney:

 1. _____.

 2. _____.

Using one of those color schemes, create your own portrait of her on a 6" x 8" card. When your painting is finished, turn the page for my version.

"Whitney"

Using watercolor as the medium for this portrait, I chose an analogous color scheme as well as a subtle, contrasting note of green (red's complement; in the shoulder strap) to gently enliven the facial colors. My analogous colors -- all warm to convey a youthful glow -- span red-violet through yellow-orange.

An alternative color scheme? Maybe a tetrad of red, orange, green and blue (with just a few touches of the green and blue).

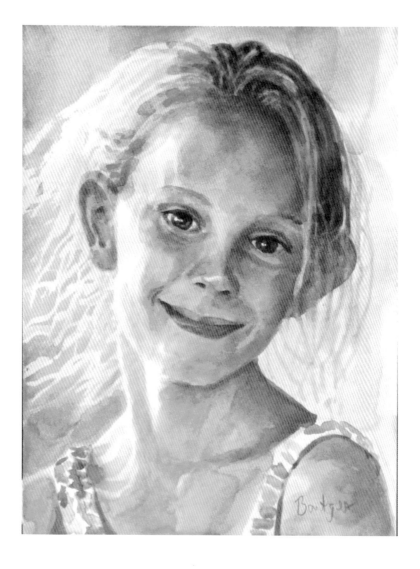

Chapter 6: How to Analyze (and Improve) a Good Painting

Here's a painting of a water lily (see Version A, below) that grows in the fish pond beside my studio. Use your color wheel to determine what color scheme I used.

. . . Yes, I played it safe by choosing analogous colors ranging on the wheel from orange to green (fig. p. 80), and I was satisfied with the results . . . for awhile.

A few weeks later, I went back to the painting, bothered that the colors didn't quite portray my original impression of the flower's rich, eye-catching beauty. So I put it back on the easel, pulled up a chair and for a few minutes just stared at the painting, a technique that forces my brain to finally focus only on that image. Then I

Version A

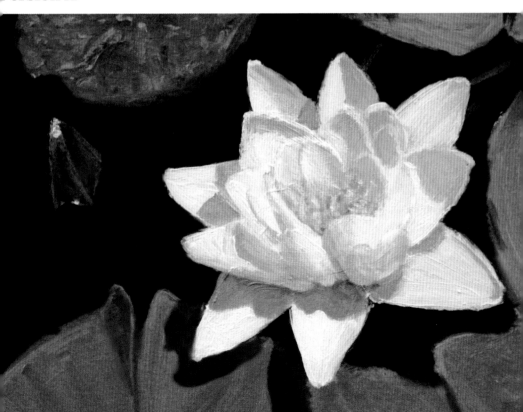

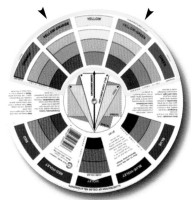

Fig. 1, Analogous

picked up the color wheel to figure out my color options.

Using your color wheel, take a few minutes to determine the color-scheme options that might improve Version A without having to redo the entire painting.

Here's how I proceeded: First, I noted that Version A basically employs just two colors – yellow-orange and yellow-green. So I went to the color wheel to see how many different dial settings connected to those two colors and found only three: 1) The analogous colors that I had used (Fig. 1), 2) A tetrad of four colors (Fig. 2), and 3) A split complementary of three colors (Fig. 3).

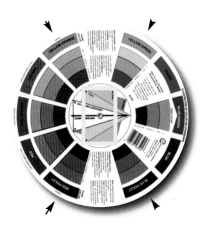

Fig. 2, Tetrad

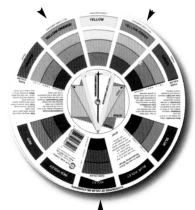

Fig. 3, Split Complementary

Next, I considered the second option, the tetrad scheme of four colors -- the current colors of yellow-orange and yellow-green plus their complements, blue-violet and red-violet. With those combinations in mind, I stared some more at the painting, trying to visualize where I could effectively add blue-violet and red-violet.

Nothing came to mind, so then I considered the third option, the split-complementary scheme, and, bingo!, I had an idea. Because the painting already employed yellow-orange and yellow-green, I

would only need to add one other color, violet, to create a split complementary. I looked to the shadows at the base of the lily blossom as a likely spot for establishing just some hints of cool violet (Version B). Note that you don't need much of any one color to satisfy a particular color scheme.

In the final analysis, both versions worked, but which one is better? Which would sell quicker in a gallery? My answer: The one that comes closer to matching my original feelings about the subject. (In other words, trust your instincts and follow your feelings. Otherwise, your painting may come across as contrived, disingenuous and impersonal. If you please yourself, your painting will please others, too.) In this case, my choice would be Version B because of the richer, more vibrant, split-complementary colors – which match my original impression of the flower.

Version B

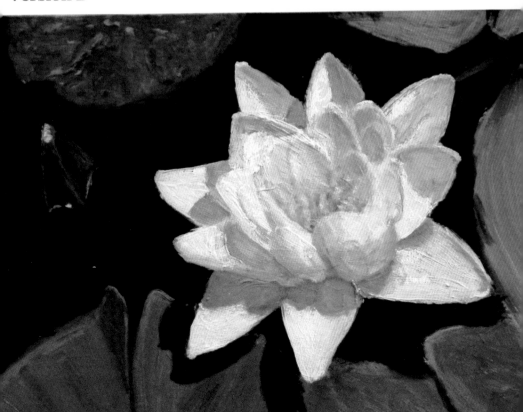

Chapter 7: How to Analyze (and Fix) a Bad Painting

All painters have done it – created a Frankenstein monster instead of a painting. In some cases, the best remedy is to follow Claude Monet's example: kick your foot through it or burn it. But before raising your boot or striking that match, let's review some alternative remedies that can often rehabilitate a monster.

Usually, the problem can be traced to one of three causes: 1) Not enough contrast, 2) Faulty perspective, or the 3) Wrong color(s).

To check the contrast (are your light areas light enough and your dark areas dark enough?), try setting your digital camera on black and white and then take a picture of the painting (or switch the photo to B&W on your computer screen). If the painting's problem is faulty contrast, that will become more apparent to you in black and white. Or, try squinting at the painting; sometimes that will make a contrast problem more obvious.

To check for a possible error in perspective, try reestablishing the painting's vanishing points and, using a ruler or string, determine if they've been accurately followed in the painting.

If you suspect that color might be the culprit, then your color wheel can be a great analytical tool for determining the exact cause(s).

As examples, on the facing page are two paintings that, when they were finished, I thought I had nailed. When I looked at them several months later, however, I realized I hadn't. The longer I looked, the uglier they got.

The questions, of course, are: "Why don't they work?" and "How can they be fixed?" With color wheel in hand, take a crack at figuring out the paintings' problems, and then the solutions . . . Once you've decided, turn the page.

"The Trout Pond"

While on vacation, I got up extra early on two consecutive mornings to set up my easel and paint this tranquil scene. But later, I realized the painting was way off the mark. What's wrong, and how can it be fixed?

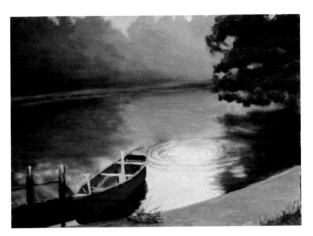

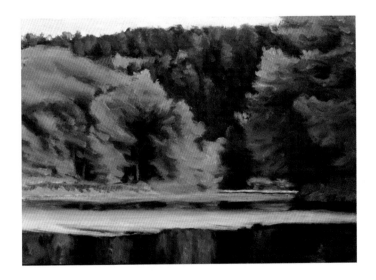

"View along the Cowpasture River"

Here's an oil sketch I painted on site. In real life, this was a beautiful view along the riverbank where I'd met Annie the farm dog (p. 73). Why doesn't the painting work? How can it be fixed?

| A | **Overall, the painting was** way too warm and bright (especially the walkway in foreground), so it failed to capture the misty, early-morning mood. I realigned my color scheme to become a tetrad of cadmium red with very muted greens, and a toned-down orange with

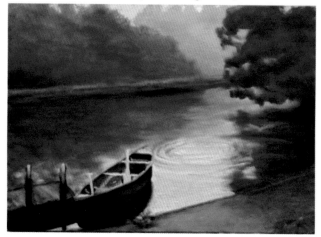

low-chroma blues. I also extended the line of bushes and trees on the opposite shore (and their reflections) to make the canoe more prominent and the scene more intimate.

| A | **I had intended this** to be a triadic color scheme of oranges, greens and violets, but I unintentionally allowed the violets to drift toward blue-violet and the oranges toward red-orange -- throwing the colors out of harmony. In addition, I should have reduced the intensity (chroma) of colors as the scene receded, added more value contrast in the water and blurred the treetops along the ridgeline. As I made these adjustments, the colors began to harmonize, and the painting gained freshness and depth. Finally, I added a few ripples across the water's surface to better establish the immediate foreground.

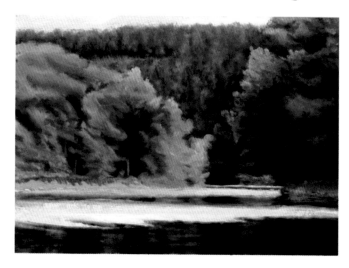

Chapter 8:
10 (Quick) Tips from the Studio

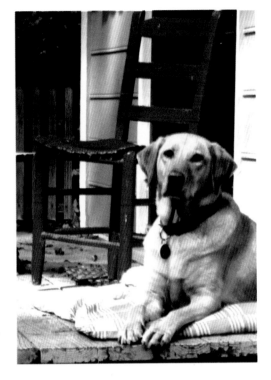

1. Before starting a painting, do a quick, preparatory color study of the subject on gessoed paper (plain paper for watercolors). This gives you the chance to work out compositional issues and to test out color schemes. J. M. W. Turner called his preliminary studies "colour beginnings."

2. Keep your eyes moving all around your painting as you work on it. Tests prove that a roving awareness of your work in progress will improve the finished piece by making it more cohesive, more unified.

3. Enroll in a studio art class at your local university, community college or art museum. You'll see how others work, how they hold their brushes, what art supplies they use, how they develop their drawings and paintings. It's exciting, inspiring, educational, productive and fun.

4. Paint the opposite. Pick a subject to paint and determine what color scheme you'd use. Then, do the entire painting in those colors' complements. This is an effective way to deepen your understanding of color. And you'll be amazed how good your finished painting will look (it's still the same color scheme, just in opposite colors).

5. Take private art lessons from world-famous artists. Select a picture of a painting by one of your all-time favorite artists and do your best to copy it. You'll learn much more than you expected about mixing colors, about composition, and about subtle shifts in hues, values and chroma.

6. For a fresh perspective and renewed objectivity, turn your painting upside down. Faults will often become more evident. You can also work on your painting while it's upside down.

Use a Mirror for a fresh perspective on your work.

7. Use a hand mirror to analyze your paintings. Again, the radical shift in viewpoint (the image will be reversed) provides renewed objectivity.

8. Once you've finished a painting, turn it to the wall and don't look at it for a week or two. Refreshed, your eyes will quickly see any areas that may still need work.

9. Visit museums and art galleries, and leaf through art magazines and picture books. Be on the lookout for paintings that are particularly appealing to you, then take the time to figure out why. Is it the color scheme? The brushwork? Subject? Mood? Composition? Keep a small notebook on your findings.

10. Every day, edge closer to the advice Richard Feynman once gave to a high-school student: "If you have any talent, or any occupation that delights you, do it, and do it to the hilt. Don't ask why, or what difficulties you may get into."

5 Great Reads

The Art Spirit, by Robert Henri. Helpful, provocative and entertaining insights by this artist who was also one of 20th-century America's most important art teachers. Students included Edward Hopper and Stuart Davis

Drawing on the Right Side of the Brain, by Betty Edwards. Hands down, the best how-to-draw book I know.

The Horn Island Logs of Walter Inglis Anderson. Observations, insights and adventures of a gifted, reclusive artist on Mississippi's Gulf Coast. When he died in 1965, Anderson left behind thousands of marvelous sculptures, ceramics and paintings, especially the watercolors.

The Journal of Eugene Delacroix. Maybe the most fascinating piece of writing by an artist you'll ever read.

The Letters of Vincent van Gogh. Maybe the second most fascinating piece of writing by an artist you'll ever read.

Glossary of Colorful Terms

Painting isn't burdened by a lot of jargon, and when it comes to color, there's just a handful of terms you ought to know.

Every color (except black and white) can be defined by three characteristics -- **Hue, Intensity** and **Value** (value being the most important to your painting).

Hue: Hue is simply the name of a particular color, such as blue, yellow-orange, red, green, etc.

Intensity: (also called 'chroma') Intensity is the relative brightness or dullness of a hue. A hue is at maximum intensity when it's squeezed straight from the tube. Its purity is at 100% because it hasn't been mixed with another color. Any color mixing dilutes and reduces a hue's intensity (which often is exactly what you want).

Value: Value is the relative lightness or darkness of a hue (often defined on a scale of 1-10; note that there's a value scale on the color-mixing side of your color wheel). When painting, getting the values right is your most important job. The relative lights and the darks must be accurate. Think about a black-and-white photograph; it's 100% dependent upon values. As an accomplished artist I know advises, "As long as you get the values right, you can get by with plenty of mistakes in a painting."

For example, the hue (color) cadmium red (at left) is at maximum intensity (chroma) straight from the tube. After being mixed with a bit of its complementary color (green) and some white, red's comparative value (at right) is about the same, but its intensity has been reduced. If more green is added, the hue would move closer and closer to gray.

Other important terms:

Tint: To lighten a hue (color) by adding white. Adding white to a color changes two things: 1) Reduces its intensity (chroma), and 2) Raises its value (makes it lighter).

Note that with watercolors, tinting is normally achieved by diluting the hue with more water, which thins the pigment and allows more of the paper's white surface to show through.

Tone: To alter a hue by adding gray. This will reduce the color's intensity and change its value (unless the color's value is about the same as the gray being added, in which case the gray would only reduce the color's intensity). With watercolors, just add touches of the color's complement (or of black) for a grayer, darker tone; add water to the mixture for a grayer, lighter tone.

Shade: To darken a hue by adding black. This will reduce its intensity and reduce its value. (Keep in mind that you can darken a hue, reduce its intensity and preserve more of its richness by adding its complementary color instead of by adding black.)

Temperature: Note that no paint color is an absolutely true hue, and as you'll see, this has an important bearing on color mixing. Every color is 'biased' either toward the 'warm colors' (such as oranges and reds) or toward the 'cool' colors (such as blues and greens). For example, the paint color ultramarine blue, although itself a cool color, has a touch of red in it so it leans toward violet and therefore is said to be a 'warm blue.' The paint color phthalo blue, on the other hand, has a touch of green in it, so it's a 'cool blue'. Cadmium yellow is a warm yellow; Hansa yellow (or lemon yellow) is a cool yellow. Cadmium red is warm; quinacridone red (or anthraquinoid red, or alizarin crimson) is cool.

In a painting, warm colors seem to stand out (they seem to advance toward the viewer) and are used most often in a painting's foreground or middle ground. Cool colors such as blues and greens seem to recede from the viewer and are often used in backgrounds (for example, to depict distant mountains).

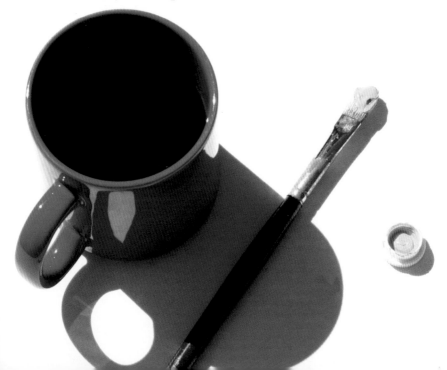

Bibliography

Barriault, Anne B. with Davidson, Kay M. *Selections from the Virginia Museum of Fine Arts.* Charlottesville: University of Virginia Press, 2007.

Birren, Faber. *History of Color in Painting.* New York: Van Nostrand Reinhold Co., 1965.

Birren, Faber. *Principles of Color.* Pennsylvania: Schiffer Publishing, 1987.

Delamare, Francois and Guineau, Bernard. *Colors: The Story of Dyes and Pigments.* New York: Harry N. Abrams, 1999.

Dunlop, Ian. *Degas.* New York: Harper & Row, 1979.

Edwards, Betty. Color: *A Course in Mastering the Art of Mixing Colors.* New York: Penguin Group, 2004.

Gaugh, Harry. *Willem de Kooning.* New York: Abbeville Press, 1983.

Kemp, Martin. *The Science of Art.* New Haven: Yale University Press, 1990.

Lindsay, Jack. *J. M. W. Turner: His Life and Work.* New York Graphic Society, 1966.

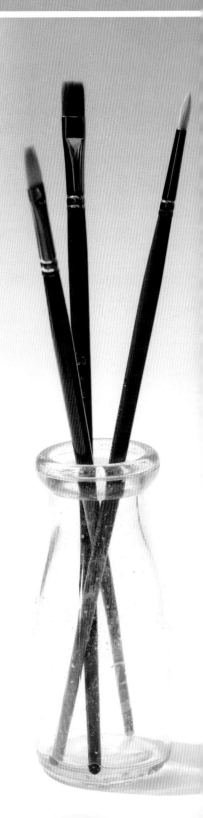

McMurry, Vick. *Mastering Color*. Cincinnati: North Light Books, 2006.

Purdon, Douglas. *Color Secrets for Glowing Oil Paintings*. Cincinnati: North Light Books, 1998.

Ravenal, John B. *Modern & Contemporary Art at the Virginia Museum of Fine Arts*. Charlottesville: University of Virginia Press, 2007.

Sidaway, Ian. *Color Mixing Bible*. New York: Watson-Guptill Publications, 2002.

Stevens, Mary Anne. *Alfred Sisley*. New Haven: Yale University Press, 1992.

Temkin, Ann. *Color Chart: Reinventing Color, 1950 – Today*. New York: Museum of Modern Art, 2008.

Image & Photo Credits

The photographic portrait on page 77 is by Diana Mitchell and reproduced with the photographer's kind permission.

All paintings (and close-up details of same) featured in Chapter 4 are from the art collection of the Virginia Museum of Fine Arts, Richmond, VA. The author gratefully acknowledges the museum's cooperation in providing these images for inclusion in this book. These paintings are catalogued as follows:

Pablo Picasso (Spanish, 1881-1973)
Jester on Horseback, 1905
Oil on composition board
39 3/8"H x 27 ¼"W; 100 cm x 69.2 cm
Virginia Museum of Fine Arts, Richmond
Collection of Mr. and Mrs. Paul Mellon.
Photo: Katherine Wetzel

Robert Scott Duncanson (American, 1821-1872)
The Quarry, ca. 1860-70, Oil on canvas
14 ½"H x 22 5/8"W; 36.83 cm x 57.47 cm
Virginia Museum of Fine Arts, Richmond
Gift of The Council of the Virginia Museum of
Fine Arts, in commemoration of its Fiftieth
Anniversary. Photo: Katherine Wetzel.
©Virginia Museum of Fine Arts

Severin Roesen (American, ca. 1815-1874)
The Abundance of Nature, ca. 1855
Oil on canvas, 56 1/8"H x 40 1/8"W
142.56 cm x 101.92 cm
Virginia Museum of Fine Arts, Richmond
The J. Harwood and Louise B. Cochrane Fund
for American Art. Photo: Katherine Wetzel.
©Virginia Museum of Fine Arts

Eastman Johnson (American, 1824-1906)
A Ride for Liberty – The Fugitive Slaves, March 2, 1862
Oil on board, 21 ½"H x 26"W; 54.5 cm x 66 cm
Virginia Museum of Fine Arts, Richmond
The Paul Mellon Collection.
©Virginia Museum of Fine Arts

Francisco Goya (Spanish, 1746-1828)
General Nicolas Philippe Guye, 1810. Oil on canvas
41 3/4"H x 33 3/8"W; 106 cm x 84.7 cm
Virginia Museum of Fine Arts, Richmond
Gift of John Lee Pratt. Photo: Ron Jennings.
©Virginia Museum of Fine Arts

Hilaire Germain Edgar Degas (French, 1834-1917)
At the Races: Before the Start, ca. 1880-92,
Oil on canvas, 15 ¾"H x 35 5/8"W; 40 cm x 89.9 cm
Virginia Museum of Fine Arts, Richmond
Collection of Mr. and Mrs. Paul Mellon.
Photo: Katherine Wetzel
©Virginia Museum of Fine Arts

Index

About the Author

A full-time artist since 1996, Dan Bartges paints mostly in oils, sometimes in watercolors. His landscapes and still lifes have been acquired by private collectors across the country and by a number of Fortune 500 companies including Marriott, Capital One, Markel, Lockheed Martin, Media General, Performance Food Group and Owens & Minor. His artwork has appeared in international and national exhibitions, in various publications and in national retail catalogs and stores from Smith & Hawken to WalMart.

Dan has conducted art workshops for cancer patients, held weekly art classes for prison inmates and lectured on 19th century art. He earned a B. A. from Hampden-Sydney College (VA), an M. A. from the University of Richmond (VA), and has studied under several prominent regional artists, at the Modlin School of Art (U. of Richmond) and the Studio School of the Virginia Museum of Fine Arts. He resides in Virginia with his family and yellow lab and enjoys tennis, squash and classic movies. His website is **www.danbartges.com.**

Acknowledgements

The author is very grateful to a number of friends and colleagues for their many contributions to this book. These include the director of the Virginia Museum of Fine Arts, Alex Nyerges, and Lee Anne Hurt and Carol Amato as well as several other members of that museum's vastly talented staff; my publisher Steve Martin of Oaklea Press; Ken Haines of The Color Wheel Company; all of the wonderful art teachers from whom I have gained knowledge and inspiration over the years including Ann Lyne, Nancy Witt, Duane Keiser, Shelly Bechtel Shepherd, Marbury Hill Brown and Marjorie Perrin; Margaret Buchanan, Margaret Megee, Jerome Maddock and Martha Steger for their sharp eyes and suggestions; and my wife and daughter for their tireless support and encouragement in so many ways.